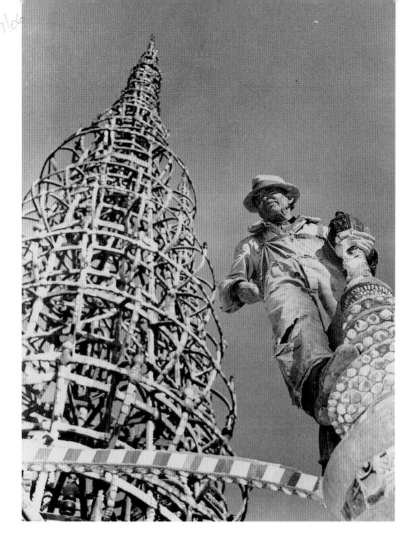

The Los Angeles
Watts Towers

Bud Goldstone and
Arloa Paquin Goldstone

The Getty Conservation Institute
and the J. Paul Getty Museum
Los Angeles

To Sam

The authors wish to thank the following for invaluable help in writing this book: Anne Ayers, gallery director at Otis College of Art and Design; Herb Rosen, writer and mentor; Howard M. Rubin, historian, for research on Los Angeles history; the Los Angeles Family History Center of the Church of Jesus Christ of Latter-day Saints for access to census data; the SPACES archives; and a special acknowledgment to Chester Goldstone for being there when needed, or not, as the case may have been, and for keeping our compass on the horizon.

The Getty Conservation Institute works internationally to further the appreciation and preservation of the world's cultural heritage for the enrichment and use of present and future generations.

This is the second volume in the Conservation and Cultural Heritage series, which aims to provide in a popular format information about selected culturally significant sites throughout the world.

SECOND PRINTING, 2002

Since the first edition, two new facts are worthy of note. The Friends of the Watts Towers Arts Center was established in late 1997 to support the center and to be an advocate for the preservation and promotion of the towers. In 1998, while excavating the foundation for the Community Redevelopment Agency's amphitheater, a construction crew dug up the remains of Rodia's 1928 red Hudson (see page 39 for the related story).

© 1997 The J. Paul Getty Trust
All rights reserved
Printed by CS Graphics, Singapore
Separations by Professional Graphics, Rockford, Illinois

Library of Congress Cataloging-in-Publication Data

Goldstone, Bud, 1926–
 The Los Angeles Watts Towers / Bud Goldstone and Arloa Paquin Goldstone.
 p. cm.
 ISBN 0-89236-491-2 (paperback)
 1. Simon Rodia's Towers (Watts, Los Angeles, Calif.) 2. Los Angeles
(Calif.)—Buildings, structures, etc. 3. Rodia, Simon, 1879–1965—Criticism
and interpretation. I. Goldstone, Arloa Paquin, 1942– . II. Title.
 NA2930.G65 1997
 725'.97'092–dc21 97–27553
 CIP

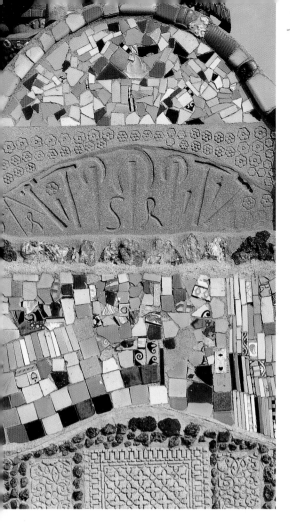

Contents

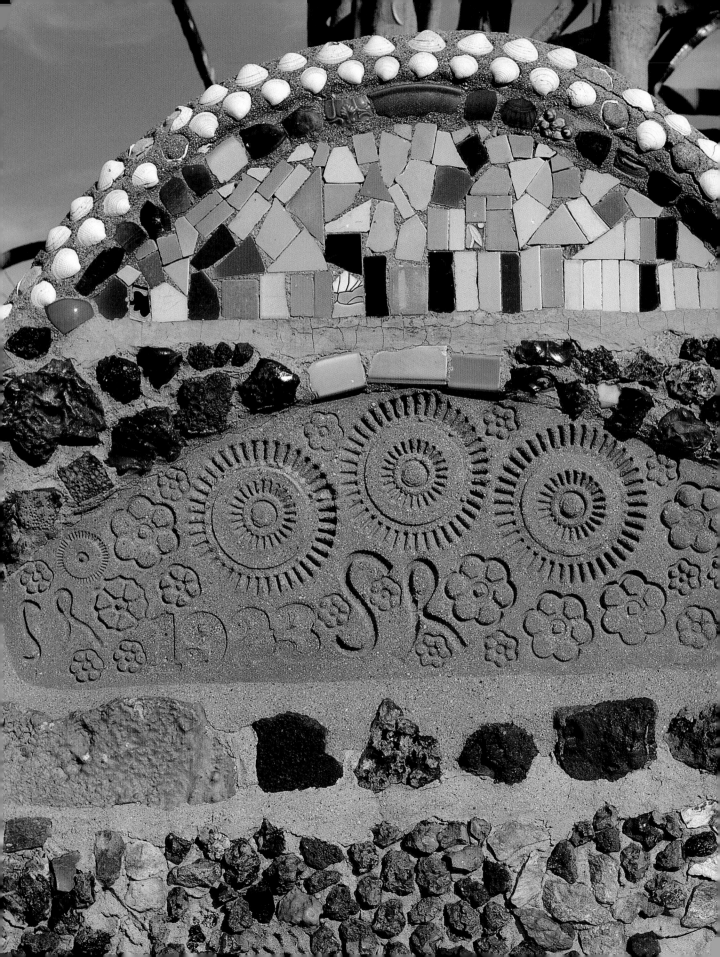

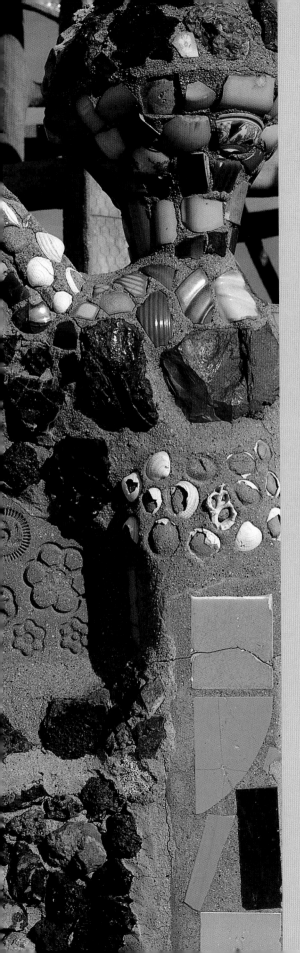

Foreword

When you first set eyes on the Watts Towers of Simon Rodia, you are struck by the amazing juxtaposition of this wondrous world of shapes, color, and intensity against the otherwise desolate plot at the dead end of a dead-end street in South-Central Los Angeles.

Part of the South Wall looking north from 107th Street. The three upper panel designs include rocks, pigmented mortar, seashells, and gear and water-faucet-handle engravements.

Photograph by Marvin Rand, 1986.

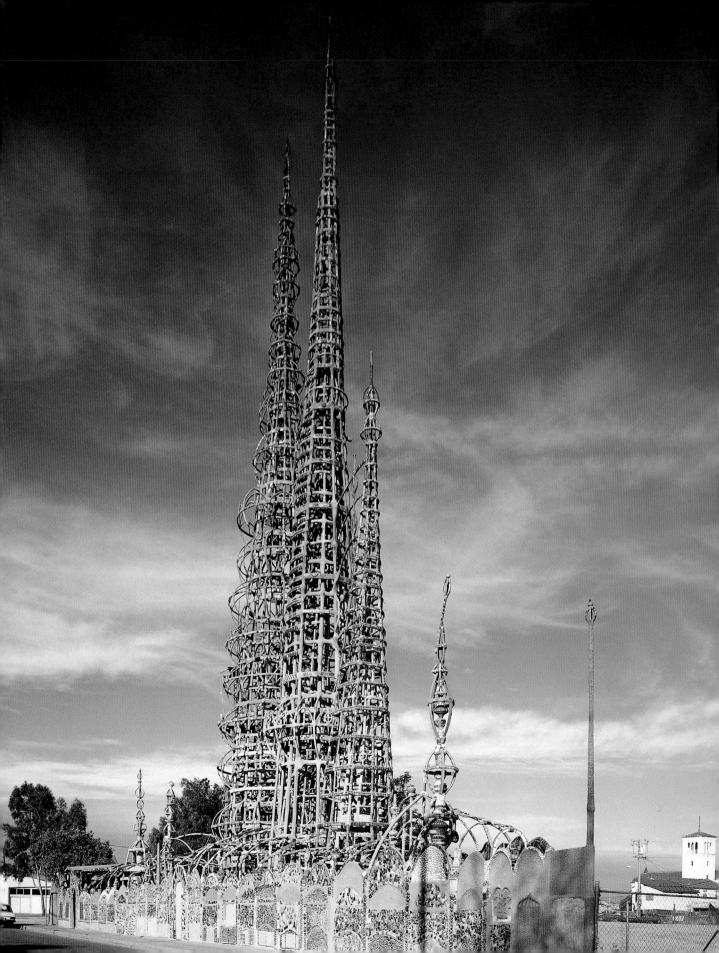

Said to be the largest structure ever made by one man alone, such a creation could never have come to exist without surpassing vision

—and without commitment, passion, and, indeed, obsession. Yet, as too often occurs with unprecedented human achievements, works that inherently reject objective measure or comparison, some mystified visitors inevitably ask, "Is it art?"

More perceptive observers praise the Watts Towers as "a unique monument to human energy, consistency, and skill" or "a gigantic flower of folk art." Another notes that in Rodia's masterpiece, "the trivial material has lost its triviality; it has become a legitimate medium, like the pigments and brush strokes of the painter. From small salvaged things, a crescendo of form, texture, and color has been made."

In 1959, when the towers' demolition seemed imminent, delegates from fifteen nations attending the Eleventh Assembly of the International Association of Art

Opposite:
The Watts Towers, view from the southeast. Right to left: the Apex spire, the Ship of Marco Polo spire, the East, Center, and West Towers.
Photograph by Marvin Rand, 1987.

Editorial page drawing, 26 April 1978, by political cartoonist Conrad. In 1977 and '78, the public objected to the deteriorating condition of the Watts Towers and the failure by the City of Los Angeles to repair damage caused by the elements.
Courtesy Los Angeles Times.

Yesterday, the Roman Forum . . . tomorrow, the Watts Towers.

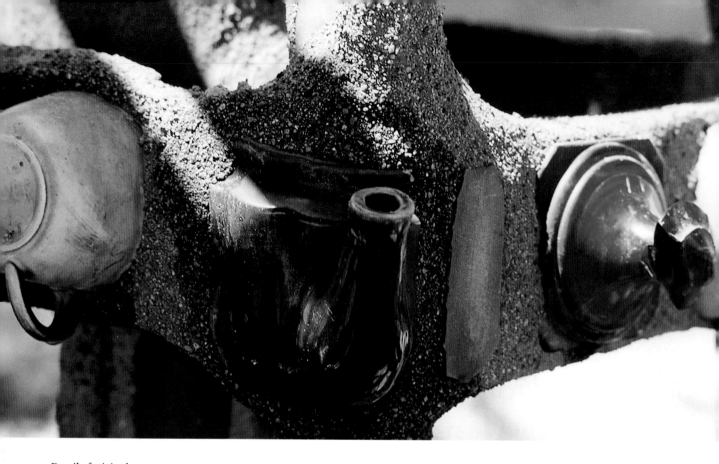

Detail of a joint between a horizontal band and vertical column.

Photograph by
Marvin Rand, 1995.

Critics passed a resolution that read in part, "We hope every measure will be taken for preservation and upkeep of this . . . structure, a unique combination of sculpture and architecture and a paramount achievement of twentieth-century folk art in the United States." Joining the international chorus of concern, New York's Museum of Modern Art championed the towers in a telegram, "Urge public and private agencies unite to save these works of great beauty and imagination which are part of our cultural heritage."

If the Watts Towers had in fact been demolished, as seemed more than likely at the time, or had been spared demolition but continued to deteriorate, the world would have suffered an incalculable cultural loss. Instead, from 1959 to the present day, private citizens, arts institutions, city, state, and federal governments have joined together in an intensive collaborative effort to honor and protect Rodia's creation.

In the almost fifty years since this collaboration first began, much has been accomplished. From the start, the residents of Watts, particularly those living on and around 107th Street, a one-block cul-de-sac that ends at the towers' eastern boundary, have unassumingly done their best to defend the towers from the ravages of vandalism. Despite the vigilance of neighbors, the Watts Towers would not stand today but for the extraordinary efforts of the dedicated private citizens who first brought Rodia's work to public attention and took the initial steps toward its rescue and restoration.

An enormous debt is owed to William Cartwright and Nicholas King, who personally purchased the towers to save them from neglect, as well as to countless members of the Committee for Simon Rodia's Towers in Watts, whose dedication and perseverance maintained the towers from 1959 to 1975. Worthy of particular honor in this regard are architects Edward Farrell and Herbert Kahn, as well as attorney Jack Levine. Especially deserving of recognition and sincere gratitude for his early, consis-

tent, and continuing dedication to the tow-ers is this book's co-author, aeronautical engineer Norman J. "Bud" Goldstone.

To the cause of saving the towers, literally thousands of people have con-tributed their time, energy, and money—from children's coins to foundation grants to city, state, and federal funds. Yet just as the towers themselves are the creation of a single visionary individual, the passionate involvement of Bud Goldstone has been essential to their continuing existence. Among many other singular contribu-tions, it was he who boldly envisioned and meticulously designed the daring load test that proved beyond doubt the structural integrity of Rodia's magnificent work. In 1959, Goldstone's brilliant brinkmanship saved the towers from impending demolition.

In 1990, co-author Arloa Paquin Goldstone researched and formulated the proposal that won National Landmark sta-tus for the towers, thus providing a crucial measure of additional protection. Particular gratitude is also due the relatives of Simon Rodia, whose gracious assistance has been essential in the effort to unearth the per-sonal history of the elusive creator.

Over the years, beyond the thousands of dollars raised by the committee from individual citizens, Rodia's Watts Towers have benefited from extensive public fund-ing. The City of Los Angeles, the State of California, and the Federal Government of the United States have contributed over $3.3 million.

For most of his eighty-six years, Rodia was presumed to be a man of mini-mal significance. Yet the eccentric artist has at last been hailed as a surpassing genius, one blessed with exceptional physical vigor and tenacious strength of character, both of sufficient quality and quantity to realize in mind and eye, by his own hand alone, a monumental and enchanting vision.

Today, some forty-two years since he gazed upon his work for the last time, Simon Rodia's Watts Towers have finally been recognized for the masterpiece they are. Scores of people, themselves gifted and accomplished, have dedicated much of their own lives to ensure that generations yet to come may be graced by the experience of the beguiling creation of an obscure, un-schooled, and often inscrutable immigrant.

At the Getty Conservation Institute, our goal is to ensure that people everywhere come to recognize, appreciate, and acknowl-edge that the Watts Towers, and similarly rare and delicate works of art, comprise pre-carious treasures of humanity. The mandate of the Getty Conservation Institute will not be fulfilled until we succeed in generating broad awareness of the pressing problems facing endangered cultural properties worldwide.

Yet solving these problems is not the exclusive privilege or responsibility of the cultural, scientific, and political elite. It is rightly a matter of general public con-cern. Cultural treasures provide a record of our human condition on both a spiritual and material plane. To decipher this record is to know our past. And so, ourselves. To preserve it is to pass that knowledge on to future generations. In this sense, the Watts Towers belong to—and must be preserved by—all of us.

Miguel Angel Corzo
Director
The Getty Conservation Institute

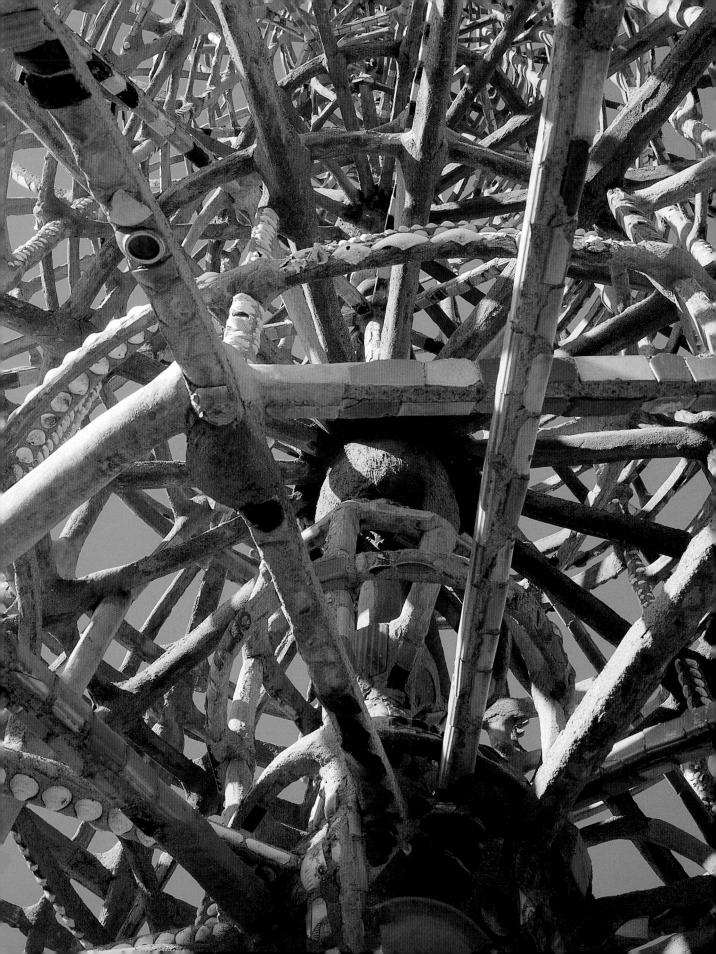

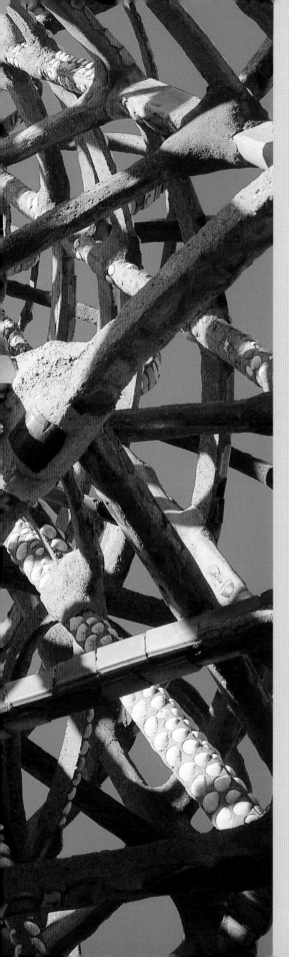

Introduction

Shortly after Dennis McLean was appointed New Zealand's ambassador to the United States in 1990, his tour of the country called for a one-day stop in Los Angeles. The local consular staff asked if he wanted to visit Disneyland. A Hollywood movie lot? Beverly Hills?

View looking up from inside the base of the West Tower.
Photograph by Marvin Rand, 1986.

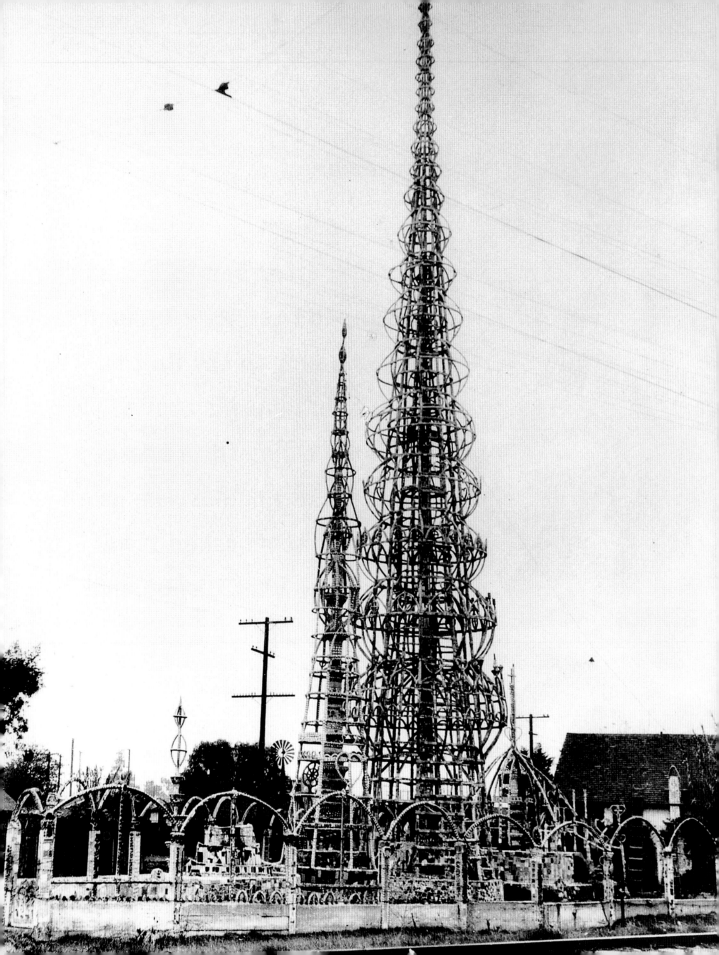

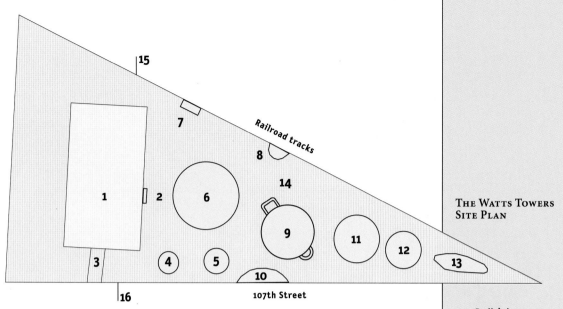

**THE WATTS TOWERS
SITE PLAN**

1. Rodia's house
2. Chimney
3. Canopy
4. A Tower
5. B Tower
6. Gazebo
7. Oven/barbecue
8. Fish pond
9. West Tower
10. Garden Spire
11. Center Tower
12. East Tower
13. Ship of Marco Polo
14. Patio floor
15. North Wall
16. South Wall

No, with only one day to spend, McLean insisted on seeing the Watts Towers of Simon Rodia.

Hundreds of people from all over the world visit the towers each month. Yet the consular staff, some of whom had lived in Southern California for ten years, had to scramble to find out exactly where these towers were and how to get there. Although Rodia's masterpiece has been internationally celebrated for decades, most Los Angeles residents still know little or nothing about the Watts Towers.

After Century City—an office, shopping, and entertainment complex— was built some 35 kilometers (20 miles) west of the towers in the 1960s, many assumed that its two tallest office structures, built by developer Ray Watt, were the "Watt's Towers." Others thought that the "Watts Tower" was the switching and maintenance building for the Red Car line and Southern Pacific Railroad. Ironically, the actual towers rose only a block away.

Opposite:
The Watts Towers site looking south with the railroad tracks in the foreground. From left to right behind the unfinished North Wall: the Ship of Marco Polo spire, the East and Center Towers, the Gazebo with an incomplete spire, and Rodia's house.

Photographer unknown, 1929. Courtesy SPACES.

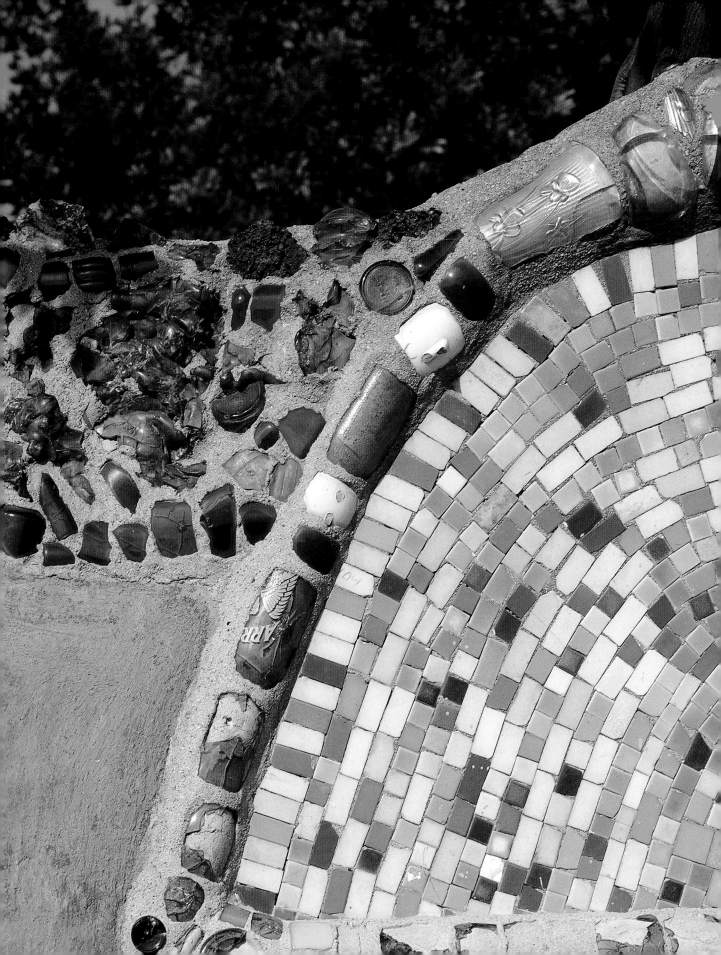

The Watts Towers are a folk art/assemblage construction in the Watts district of South-Central Los Angeles. They were built by one man, Simon Rodia, an Italian immigrant, working alone, over a thirty-four-year period, 1921–55.

When Rodia, at age forty-two, bought a humble house on a narrow, triangular lot at 1765 East 107th Street in 1921, he immediately set to work. The lot extends 42 meters (138 feet) along 107th Street on the south, 21 meters (69 feet) on the west, and 47 meters (155 feet) along a now-empty strip on the north, where the trolley car and railroad tracks once ran. On this compact 400-square-meter (1/10-acre) site, Rodia built a collection of seventeen sculptures. The three tall spires, two walls, gazebo, several small towers, ship, patio, and other structures he collectively called Nuestro Pueblo (our town) are now known as the Watts Towers.

Rodia salvaged whatever miscellaneous discards he could find in his neighborhood or at his job sites. With the minimal wages he made as a cement finisher and tile maker, he bought bags of sand and cement and steel. When not working for money to survive, he would make his sculptures. Neighbors said he often worked all night, then went to his job the next morning. Sometimes, they recalled, he would follow this routine for several days, not even stopping to eat.

No one in Watts knew much about Rodia, except that he was the only Italian

Opposite:
Detail of the top of
a South Wall panel,
east of the garage
door, with rocks, slag,
and bottle parts.

Photograph by
Marvin Rand, 1987.

FRONT PAGE STORIES

Some of the headlines as they appeared on the front page of the *Los Angeles Times* during the construction of the Watts Towers.

3 July 1921

"Times" Knockout Photograph [of Georges Carpentier by Jack Dempsey] Sent by Wire

15 November 1921

New Sensation in Arbuckle Case

3 February 1922

Arbuckle Abandons Hope

17 February 1923

Tutenkhamun Tomb Opened; Not Disturbed

3 August 1923

Harding Dies Suddenly of Apoplexy: Calvin Coolidge Now Is President

22 July 1925

Scopes Conviction Paves Way for Legal Struggle

30 July 1925

Plaza Site for Union Depot Here Approved

19 May 1926

Aimee Semple McPherson Believed Bathing Victim

22 May 1927

Lindbergh Reaches Paris Amid Riot of Vast Mob

14 March 1928

200 Dead, 300 Missing, $7,000,000 Loss in St. Francis Dam Disaster

6 June 1930

Los Angeles City Population 1,231,730; Los Angeles County's Total 2,199,557

29 March 1931

Are Gangsters Building Another Chicago Here?

2 March 1932

Lindbergh Son Seized by Kidnapers

9 November 1932

Roosevelt Is Elected President; M'Adoo Senator for California

11 March 1933

Scores Perish in Southland Quake

6 December 1933

Rum Flows in Quietly

2 January 1934

Thirty-Six on Death Roster in Record 8.27-inch Deluge

2 May 1935

Send-a-Dime Letters Swamping Postoffice

17 August 1935

Rogers-Post Arctic Death Crash Related

14 February 1936

City Police Patrols Halt 1000 at State's Borders

8 March 1936

Ann Rork Getty Files Divorce Suit in Nevada

10 December 1936

King's Abdication Set for Today

7 May 1937

Zeppelin Blast Kills Thirty-Five

3 July 1937

Amelia Earhart Lost in Pacific; Radio Flashes Faint SOS

13 December 1937

Heavy Seas Rip Out Three Piers

Japanese Admit Sinking U.S. Ship

4 March 1938

Known Deaths Reach Seventy as Storm Flood Waters Recede

30 September 1938

Four-Power Peace Pact Signed

1 September 1939

German Army Invades Poland

11 July 1940

Los Angeles Population 1,496,792

(continued)

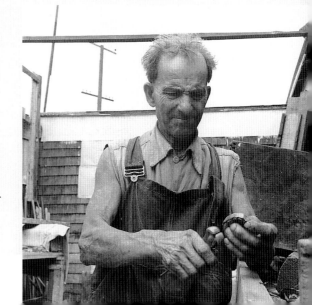

Rodia in his outdoor workshop at the Watts Towers.

Photographer unknown, 1950. Courtesy Archive Photos.

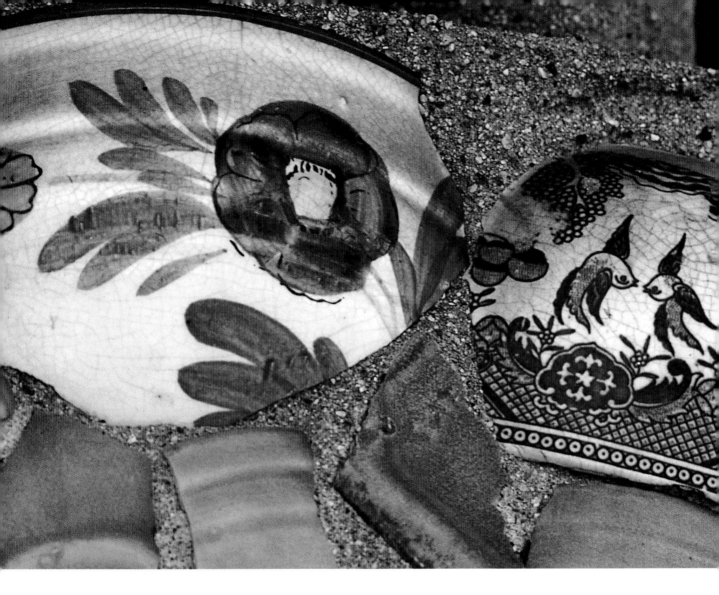

Detail of ornaments on a horizontal band.

Photograph by
Marvin Rand, ca. 1995.

in the neighborhood, and that hardly any-
one outside of Watts seemed to care much
about him or his creation. Until after World
War II, Watts was an out-of-the-way "bed-
room community" surrounded by truck
farms. To add to the mystery, whenever a
reporter or author did interview him,
Rodia never clearly explained what the tow-
ers were or why he was building them.
Almost everyone who talked to him left
with a new and different story. But one
thing Simon Rodia did proclaim consis-
tently, repeatedly, with fierce determina-
tion, "I'm gonna do something. I'm gonna
do something. I'm gonna do something."[1]
That he did.

The tallest tower rises almost 30
meters (100 feet). The entire construction

was built without bolts, rivets, or welds.
Rodia simply bent scrap steel into the
shape he wanted, wrapped around the steel
whatever kind of wire and wire mesh he
had on hand, and held it all together with
his own mixture of cement. As various
parts of the structure hardened, he would
climb up on them to continue building
higher. Historical research and conserva-
tion of the sculptures have revealed that
he even rebuilt major areas several times.
It is debatable whether he ever really fin-
ished his work.

In the mid 1950s, when he was seventy-
six years old, Rodia abandoned the site.
Soon thereafter some members of the City
of Los Angeles bureaucracy considered the
towers unstable and urged their demoli-

tion. Fortunately, a highly publicized load test dramatically demonstrated the structural integrity of Rodia's design, building techniques, and materials.

Rodia's towers withstood the test with flying colors. This victory did not surprise architect/inventor R. Buckminster Fuller and cultural historian Jacob Bronowski since both considered Rodia exceptionally advanced in his methods and concepts as a structural engineer.

"Sam . . . came in with what today would be called ferro-cement structure," Fuller noted in 1965. "He thought in terms of very thin shells with a great deal of wire mesh deeply [embedded] in it—thin-shelled reinforced concrete—which is the great accomplishment of recent European building in dome structure. He had that well in advance." [2]

"So the Watts Towers have survived," Bronowski wrote in *The Ascent of Man.* "The work of Simon Rodia's hands, a monument in the twentieth century to take us back to the simple, happy, fundamental skill from which our knowledge of the laws of mechanics grows." [3]

In 1965, as a tribute to Rodia after his death, the Italian sculptor Gio Pomodoro stated, "With leftovers from his daily bread, he created a sculptural garden. Hail to the innocent Gaudí of California, who destroyed the myths of Disneyland and movieland in a swift, isolated competition." [4]

Over the years, Rodia's Watts Towers have been variously labeled by expert observers as idiosyncratic, folk art, caprice, and fine art. He has been at once hailed for single-minded dedication and scolded for obsessive sense of mission. Yet however one chooses to approach the towers, their truth and beauty are by now firmly established in the eyes of countless astonished and admiring beholders.

FRONT PAGE STORIES
(continued)

30 December 1940
Six-Million-Dollar Arroyo Seco Parkway Opened

11 December 1941
Axis Declares War on America

24 February 1942
Submarine Shells Southland Oil Field

26 April 1943
L.A. in Blackout for 56 Minutes

9 June 1943
City Goes Five Days Without Traffic Deaths

27 July 1943
Italy Peace Bid Reported

6 June 1944
Invasion! Allied Landings Begun in France, Eisenhower Says

18 September 1944
City 'Smog' Laid to Dozen Causes

Lana Turner's Ex-Mate and Turhan Bey Scuffle

13 April 1945
Roosevelt Dead! Cerebral Hemorrhage Proves Fatal; President Truman Sworn in Office

7 May 1945
V-E Day!

15 August 1945
Peace! Japs Accept Allies' Terms Unreservedly

2 October 1946
Rioting Marks Film Strike; 16 Injured and 13 Arrested

11 December 1947
Film Men Surrender in U.S. Contempt Case

31 January 1948
Terrible Conflict Brewing Over Gandhi Assassination

4 November 1948
Transit Lines Get Straight 10c Fare

12 January 1949
Snow Falls for Third Night, Tangling Southland Traffic

1 March 1949
PE Seeks to Replace Cars with Busses on 11 of 17 Lines

21 July 1949
All-Out War Opened on Gangs

7 February 1950
Mystery Pair in Car Hunted in Bombing of Cohen Home

Southland Rain Sets Seven Year Record

11 April 1951
Truman Fires MacArthur

19 January 1952
Weatherman Says Southland Storm Over

7 February 1952
George VI Mourned; Elizabeth Flies Home

17 March 1952
'Baby Tornado' Spreads Damage in Santa Monica

21 July 1952
Big Quake Rocks L.A.

6 March 1953
Stalin Dies; Mystery Veils Successor

27 May 1953
Poulson Elected Mayor; Auditorium and Airport Bond Proposition Lag

2 June 1953
Britons Conquer Mt. Everest as 'Gift' for Queen

3 June 1953
New-Crowned Queen Hailed

20 June 1953
Rosenbergs Die; Pair Executed for Atom Spying

22 August 1953
Housing Sites Offered City at Low Price

2 March 1954
Fanatics Shoot Five in Congress

18 May 1954
Supreme Court Outlaws Segregation in Schools

NOTES

1. William Hale, *The Towers.* Los Angeles: Creative Film Society, 1953.

2. *Los Angeles Free Press* 2, no. 30 (issue 53), 23 July 1965.

3. Jacob Bronowski. *The Ascent of Man.* Boston: Little, Brown & Co., 1974: 118–21.

4. *Los Angeles Free Press* 2, no. 30 (issue 53), 23 July 1965.

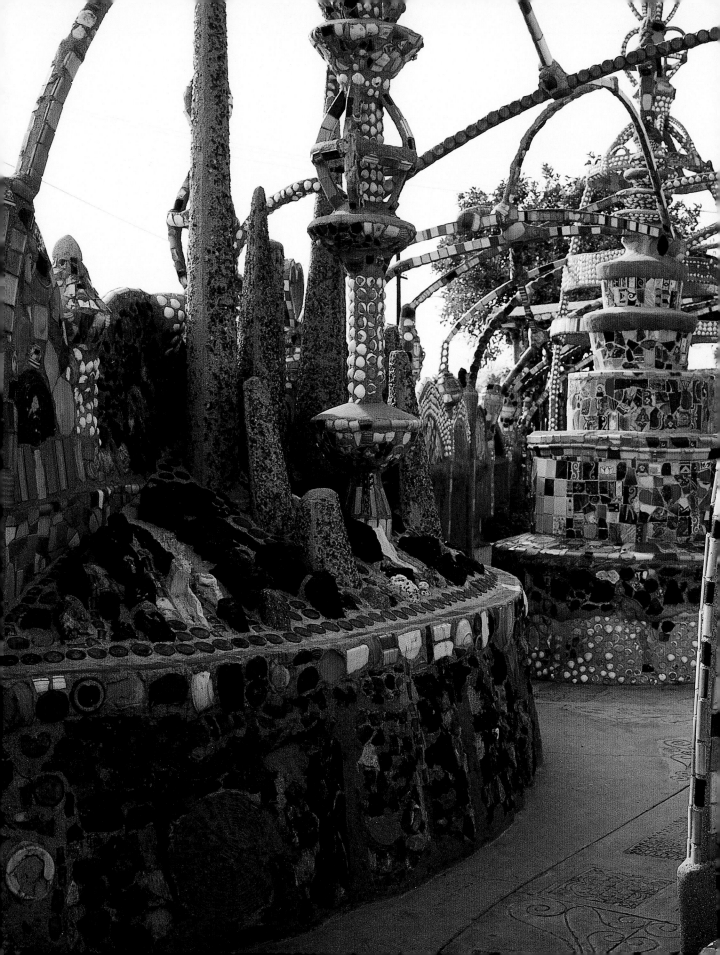

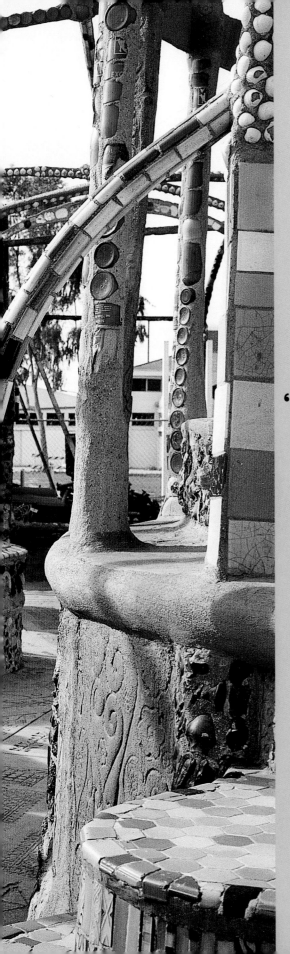

What Are They?

Everyone who visits the Watts Towers comes away with one basic question: "What are they?" Are they folk art, architecture, buildings, or assemblage? Even professionals in the art community haven't been able to agree on the answer.

View looking south-west. From left to right: the South Wall, the base of the Garden Spire, the B Tower, and the base of the West Tower.

Photograph by Marvin Rand, 1986.

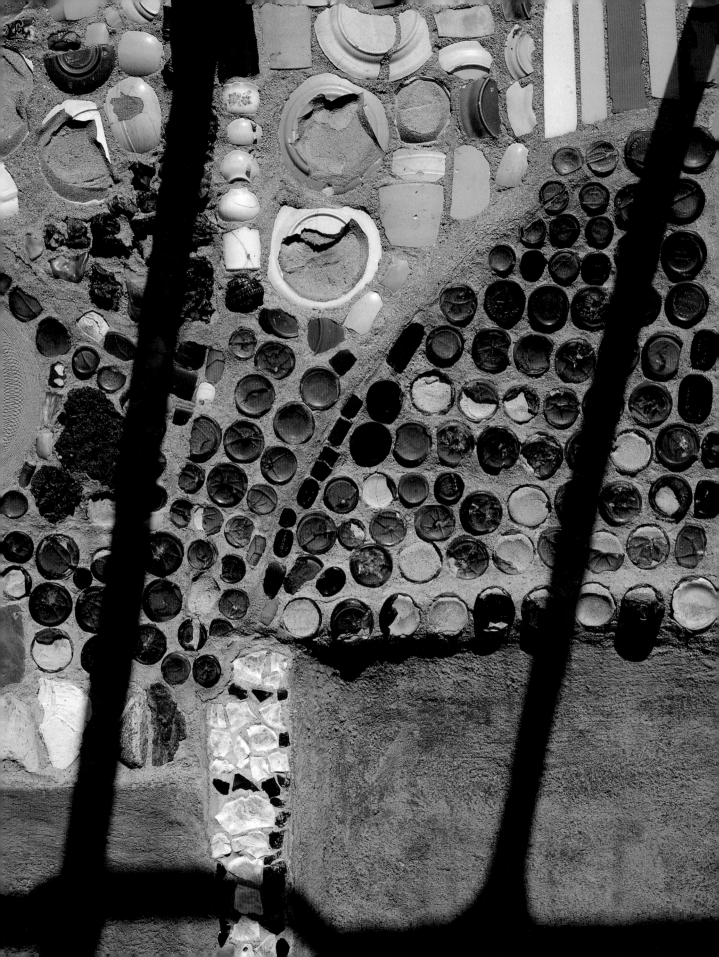

Perhaps the difficulty in categorizing them is not surprising given their creator.

As Calvin Trillin in his 1965 article in the *New Yorker* stated, "If a man who has not labeled himself an artist happens to produce a work of art, he is likely to cause a lot of confusion and inconvenience."[1]

One thing on which all agree: the Watts Towers are definitely part of the development of twentieth-century American art. "If expertise put together a list of fifteen masterpieces, Simon Rodia's amazing structure on 107th Place [*sic*] would have to be on it," asserted art critic William Wilson in the *Los Angeles Times*.[2]

The towers have been discussed in many articles and books. Reyner Banham, the architecture critic, wrote, "Alone of all the buildings in Los Angeles, they are almost too well known to need description. They are unlike anything else in the world. Their actual presence is testimony to a genuinely original creative spirit."[3]

Roger Cardinal wrote of the towers, "The surrounding wall is high enough to dismiss the outer world from one's consciousness: the array of disparate parts takes on an exhilarating coherence and forms a harmonious space set apart, a closed garden which nourishes the sense of won-

Opposite:
Detail of the North Wall, looking north.

Photograph by Marvin Rand, ca. 1987.

Richard Oginz. Watts Towers, *1994. Ink on paper. 5¹⁄₄ × 7¹⁄₄ inches. Collection of the artist.*

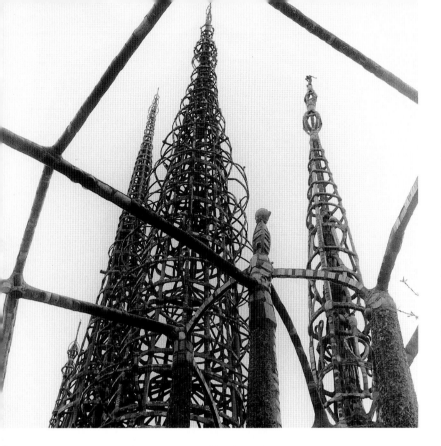

The Watts Towers looking southeast from the patio. The spires from left to right are the East, Center, and West Towers, and the Gazebo.

Photograph by Seymour Rosen, ca. 1967. Courtesy SPACES.

Richard Oginz. Head, 1975, inspired by the Watts Towers. Wood and cement. 6 × 4 × 3 feet.

Collection of the Los Angeles County Museum of Art.

derment and refuses the ordinariness of its suburban context."[4]

After climbing to the top of one of the structures, William Seitz described the towers as, "a unique creation of inspiring power and beauty, a masterpiece of assemblage. To dismiss this unique creation as a quaint folly—as one more bizarre production of an eccentric folk artist—would be an error. Less capricious than many of Gaudí's structures, Rodia's towers are much more than uncontrolled accretions of junk. His innate artistry is evident everywhere in masterful contrasts and analogies of sizes and textures, man-made and natural materials, organic and geometric form, monochromatic and complementary color schemes, and opacity and transparency."[5]

Sculptor Richard Oginz sees the towers as a vivid and instructive metaphor of the artist's mind—a mind highly literal in its perception of the direct and immediate relationship between cause and effect.

Putting the work into historical context, Daniel F. Mendelowitz stated, "Starting his work thirty years before [others], Rodia created a monument to the art of assemblage."[6] Art historian Peter Boswell wrote, "Assemblage has been perhaps the most vital art form in California for the past thirty years. It is a tradition that took root in stony soil. Before the 1940s, the only significant assemblage work on the West Coast was by self-taught 'naive' or 'outsider' artists who had only a rudimentary knowledge of art traditions and felt no particular ties to modern art."[7] Rodia fits squarely into this tradition.

Art historian Philip Brookman added, "The Watts Towers had been under construction in Los Angeles for twenty years when the United States entered the Second World War, a historic moment considered to mark the beginning of assemblage in California. Its [the towers]

handmade, free-form structure became
one of the first and most important assem-
bled constructions in California and has
inspired generations of artists."[8]

Among the California assemblage
artists inspired by Rodia are George Herms,
Betty Saar, John Outterbridge, and Ed
Kienholz. According to Boswell, "After
seeing reproductions of Rodia's towers
in Seitz's *The Art of Assemblage* in 1961,
artist George Herms developed a respect
for Rodia's achievement that quickly
'blossomed into a full-blown love affair.'
A champion of the towers, Herms makes
an effort to accompany out-of-town and
foreign friends and visitors to the Watts
Towers whenever he can."[9] Artist and
architect Niki de Saint Phalle, in her work
in Tuscany, has also claimed inspiration
from Rodia.[10]

Rick Oginz was so inspired by the
Watts Towers on one week-long trip while
in graduate school that he moved to Los
Angeles to be close to them. He sees Rodia's
work as grappling with the fulfillment of
a basic human desire, as well as the solu-
tion to a fundamental human problem,
both existing since the dawn of civilization:
how to mark one's home place. Rodia's
intention, Oginz suggests, was to create
a mnemonic device, a "memory-trigger,"
towering on the horizon of consciousness.
In the physical world, it would serve as
a tangible landmark for Rodia. It would
claim as his own an otherwise nondescript
place in an otherwise flat and mundane
landscape, relatively desolate both literally
and figuratively. Reflecting the aesthetic
memories of Rodia's Italian village roots,
the sculptures also served as a spiritual
landmark, subtly helping the artist "find
his way home."

"The work and the structure are both
scaled to Rodia," Oginz observes, "so that
he didn't need scaffolding. He could use

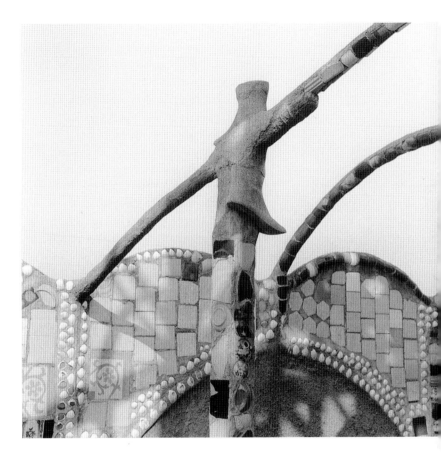

*Detail of boots,
shaped in solid mor-
tar from an unknown
mold, on a post and
overhead adjacent to
the North Wall, view
looking north.*

*Photograph by
Seymour Rosen, 1965.
Courtesy SPACES.*

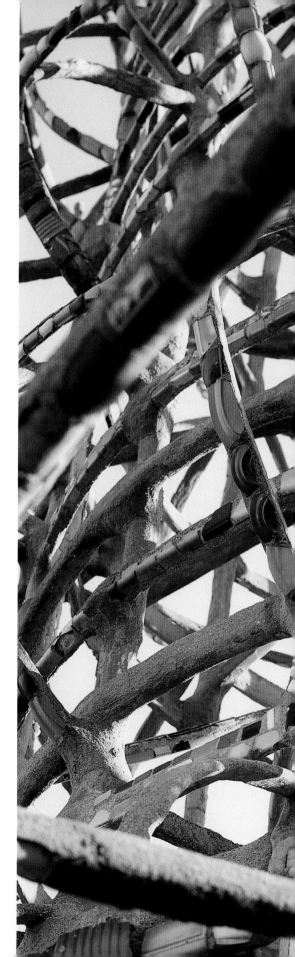

View of the West Tower looking northeast.

Photograph by
Marvin Rand, 1986.

the structure itself to climb on. But to do that, he had to make it conform to his own physique—his step, his reach. And he did that consistently.[11]

"The skeletal structure, that's what makes a 100-foot tower seem so lofty. It's exceedingly lacy and intricate. If it were a monolithic structure, imposing itself upon the viewer, even if you knew it was 100 feet tall, you would experience it as much smaller. In this regard, the Watts Towers seem to me unique. I can't think of any other work, whether sculpture or architecture, that so effectively embodies the monumental.

"By contrast, consider the Eiffel Tower. Even though its structure is skeletal, its effect is monolithic. Why? Because the scale is mechanical, not human. The fact that Rodia's sculpture is scaled to the stature of a particular man, that's what gives his work such integrity, makes it seem so monumental."

Rodia's monument, its ethereal structure intensely expressive of his urgent need and compelling desire to build it, proves to be the measure of the man, just as the man himself provided the physical measure of his work. Everything in and about the towers—every span, member, arch, and portal—is precisely scaled to the extents and limitations of Rodia's diminutive stature. The work is directly and immediately determined by his innate capacity to lift so much, stretch so far, climb so high, to create at the extreme limits of his being, to go that far and, physically, no farther.

"Aesthetically," Oginz elaborates, "take any portion of the towers, and you'll find so much going on. It's what I call 'density of incident.' This was Rodia's heroic effort to express himself, a profoundly complex man, verbally inarticulate, largely isolated within his own mind. Personally, I don't share the modernist

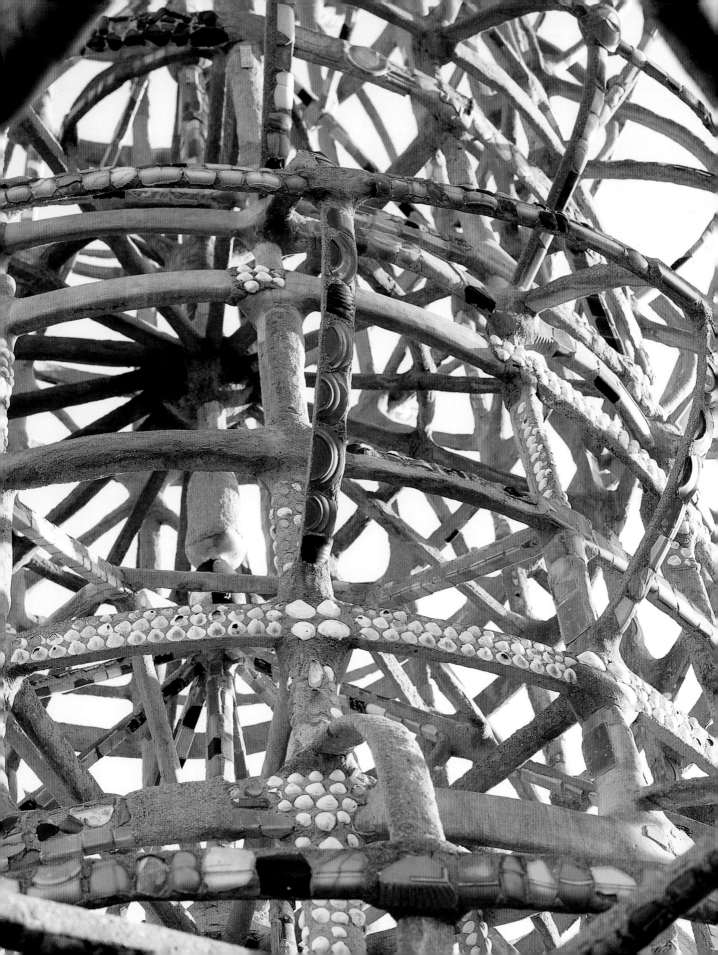

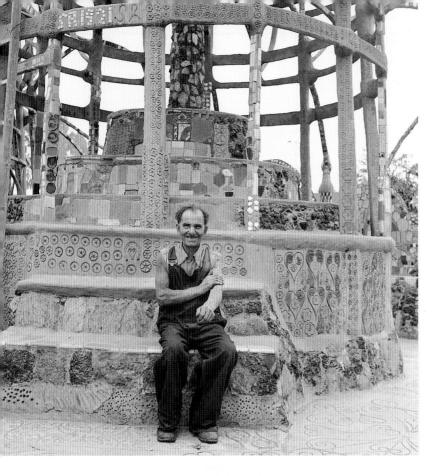

Rodia on the steps of the West Tower, view looking north. Note Rodia's initials "SR" and the date "1921" in the horizontal band and his ladder on the left.

Photographer unknown, ca. 1950. Courtesy Archive Photos.

The sons of architect Herbert Kahn— Cory, Peter, and Phil— at the towers in February, 1959.

Photograph by Herbert Kahn.

reverence for emptiness. It makes me nervous. And I think it made Rodia nervous too. Whether with textured cement, pieces of glass, shards of pottery, or fragments of tile, almost every surface of the towers is densely articulated. In their complexity of color and design, certain passages are simply breathtaking."

The quantity and frequency of aesthetic statements made throughout the sculpture brilliantly reflect the devotion demanded to conceive and complete the work. Rodia's statement is at once profoundly humble and immensely proud.

"The intense density of articulation in Rodia's work is both a design theme and an aspect of his personal character," Oginz marvels. "No matter what they might think of the work itself, he didn't want anyone ever to suppose that making it had been easy. Rodia was determined that everyone who saw the towers would agree he had worked very hard to build it. If nothing else, the world would know one thing: Simon Rodia did do something big and took no shortcuts."

His "something big" encourages us to engage in serious thinking about the nature and characteristics of art. Whether the Watts Towers are labeled folk art, assemblage, sculpture, architecture, ad-hoc art, *bricolage,* Outsider Art, or anything else is ultimately not important. Why not just experience them for what they are and make up your own mind? Or simply listen to children, observers not yet exposed to the burdensome cultural and aesthetic assumptions that civilization imposes, and thus more willing to accept the towers on their own terms.

In the wide eyes and open minds of children, the Watts Towers exist simply for the people of Los Angeles and the world to enjoy. A first-grader once remarked, "Rodia must have been rich. He has two

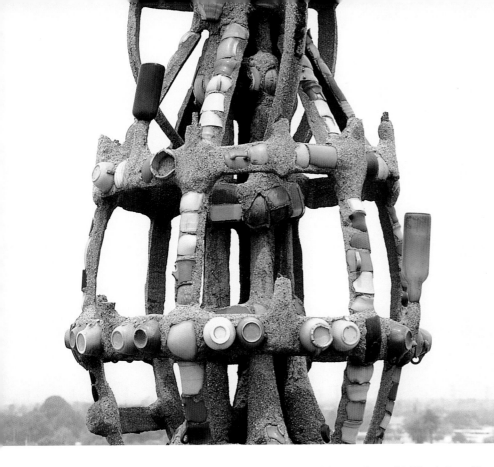

*Portion of the
West Tower spire.*

*Photograph by
Seymour Rosen, ca. 1981.
Courtesy SPACES.*

mailboxes!" Another noted, "He has crayon colors." A particularly active child complained, "Why can't *I* climb on the towers? Sam got to." And another exclaimed, "I like the shapes; they're so tall!" In William Hale's 1953 film, one child, asked why Rodia built the towers, replied, "To make a pretty scenery, I think. And make that place famous."[12]

NOTES

1. Calvin Trillin. "A Reporter at Large: I Know I Want to Do Something." *The New Yorker,* 29 May 1965: 72–120.

2. William Wilson. *Los Angeles Times,* 23 April 1978.

3. Reyner Banham. *Los Angeles: The Architecture of Four Ecologies.* England: The Penguin Press, 1971.

4. Roger Cardinal. *Outsider Art.* New York: Praeger, 1972.

5. William Seitz. *The Art of Assemblage.* New York: The Museum of Modern Art, 1961.

6. Daniel Franklin Mendelowitz. *A History of American Art.* New York: Holt, Rinehart and Winston, Inc., 1970.

7. Peter Boswell. "Beat and Beyond: The Rise of Assemblage Sculpture in California." In *Forty Years of California Assemblage.* Los Angeles: Wight Art Gallery, UCLA, 1989.

8. Philip Brookman. "California Assemblage: The Mixed Message." In *Forty Years of California Assemblage.* Los Angeles: Wight Art Gallery, UCLA, 1989.

9. C. Eliel and B. Freeman. "Contemporary Artists and Outsider Art." In *Parallel Visions: Modern Artists and Outsider Art.* Los Angeles: Los Angeles County Museum of Art, 1992.

10. Ibid.

11. Personal conversation with Richard Oginz, April 1997.

12. William Hale. *The Towers.* Los Angeles: Creative Film Society, 1953.

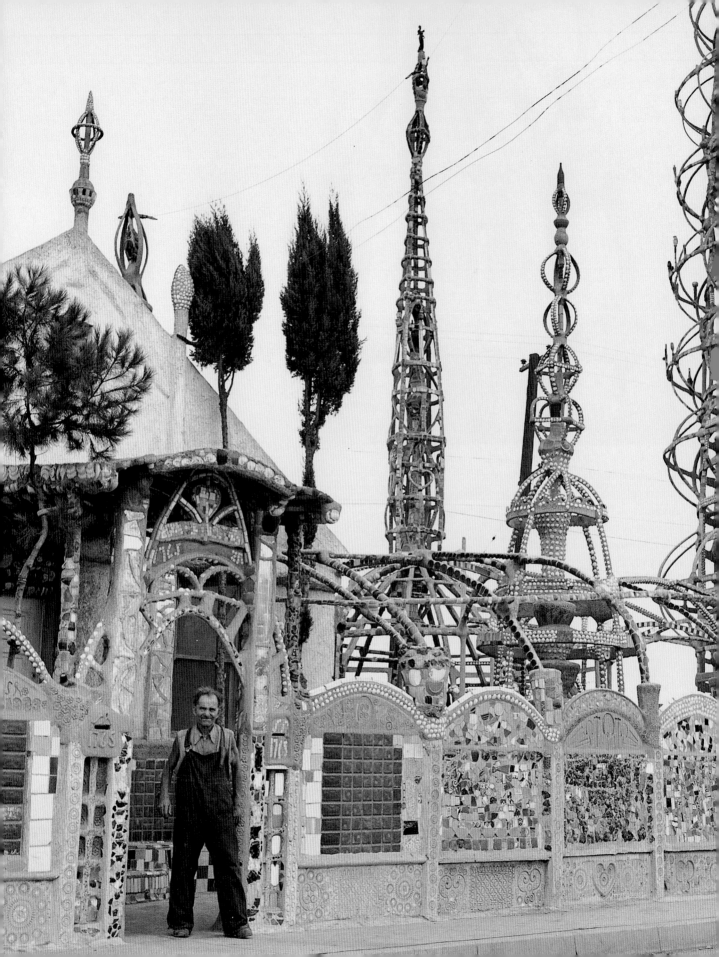

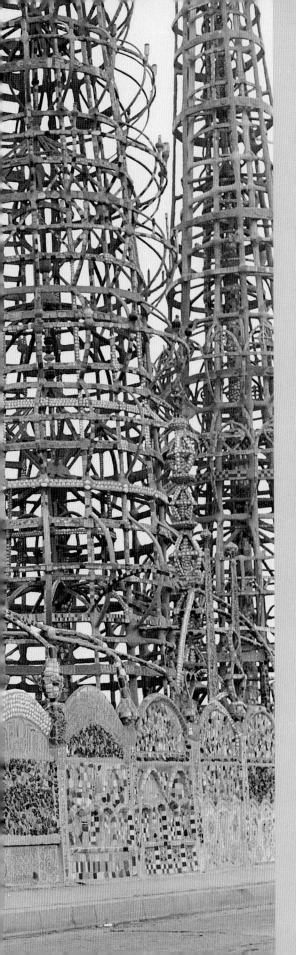

The Life of the Artist

Sabato Rodia was born on 12 February 1879, in Ribottoli, Italy, a tiny village on the north slope of Monte Faggeto, which, at 1,296 meters (4,250 feet), is 76 meters (250 feet) higher than nearby Mount Vesuvius.[1]

Rodia in front of the entrance to his house with the spires of the Gazebo and the A Tower, center, and the West Tower on the right, looking northeast from 107th Street.

Photographer unknown, ca. 1950. Courtesy Archive Photos.

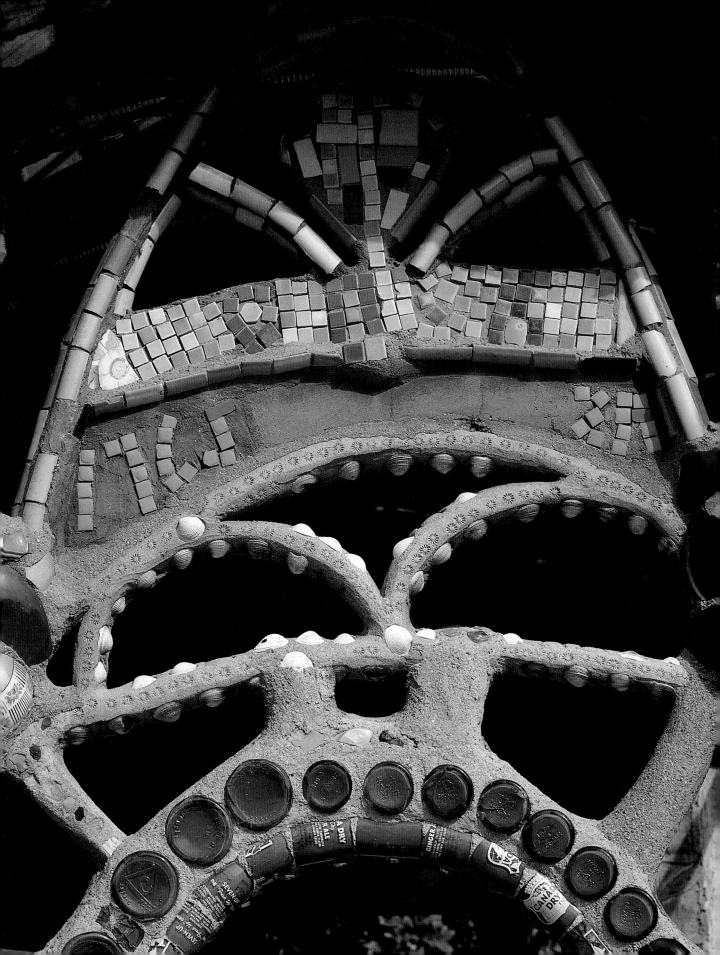

Ribottoli is east of Naples and south of Serino, in the province of Avellino and region of Campania. The village lies close to the Sabato River.

Rodia's parents named him either for the river or the Italian word for Saturday. When Sabato was born, his father, Francesco, was thirty; his mother, Nicoletta Cirino, twenty-seven. According to members of the family, Sabato had at least two brothers, Ricardo and Antonio, and a sister, Angelina. Francesco and Nicoletta were members of the peasant class, although the family owned a little land.

Rodia's birthplace is also very near the town of Nola. Here, Rodia's artistic imagery may have been inspired by childhood exposure to the great ceremonial towers, six stories high and weighing more than three tons, which were paraded on 21, 22, and 23 June during the annual Giglio festival. The festival has been an integral part of life in Nola since the late Middle Ages, when it began as a celebration to commemorate the kidnapping, liberation, and return of Santo Paulinus, then Bishop of Nola. Paulinus and other inhabitants of the town were abducted and held prisoner in North Africa sometime during the fifth century. They were set free when Paulinus

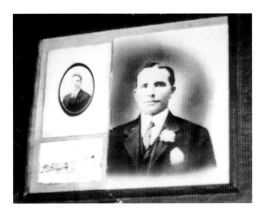

Opposite:
The front entrance detail. Rodia used blue tiles to form the street address, "1765" and his initials, "sʀ" above the door. It is not known why the "s" is backwards; possibly due to Rodia's limited writing ability.
Photograph by Marvin Rand, 1986.

Rodia as a young man in around 1915 from a picture on the bulletin board in his house.
Photographer unknown. Still from The Towers, *1953. Courtesy William Hale.*

successfully interpreted a dream that had been troubling one of his captors. Bishop Paulinus was later canonized and became the town's patron saint.[2]

The festival was originated by the eight craft guilds of Nola and consists of a procession of eight wood and paper towers (one for each craft guild) and a ship, symbolizing the one bringing Paulinus safely back to Italy. The general shape and construction details of Rodia's three tallest towers—specifically the center column, supporting vertical legs, and external bands—are remarkably similar to those of the towers carried on the shoulders of Nola residents in the festival each year. The ship Rodia built on his Watts property is almost identical to the one carried in the Giglio festival.

The ship Rodia created can also perhaps be seen as a metaphor for his long journey to a new country. He arrived here by ship, probably through New York's Ellis Island, although an extensive search of immigration records failed to identify either the vessel that brought him from Italy or the year that he arrived. U.S. census data from the years 1900, 1910, and 1920, however, do shed some light on some of the mysteries of Rodia's life during the first decades of the century.

Sabato was about fifteen when he sailed for America, possibly to avoid being drafted into the Italian army. An older brother, Ricardo, had made the journey to the United States two years earlier and settled in Pennsylvania, so Sabato went to live with him. Ricardo was working in the coal fields as a miner. Soon after his arrival, finding that the mines were dominated by Irish immigrants, Ricardo had changed his name to Dick Sullivan to disguise his Italian origin.[3] For his part, young Sabato could not read or write Italian, let alone English, and had no training for any job.

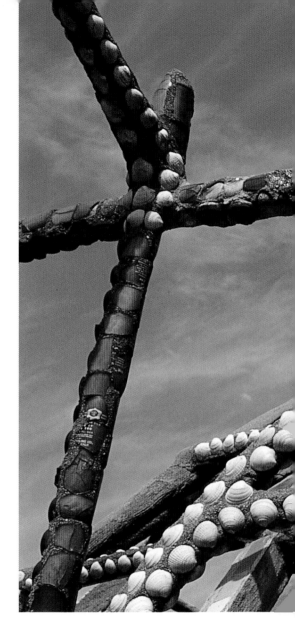

Though determined to achieve his own version of the American Dream, Sabato firmly refused to discard his Italian identity simply to work in a coal mine.

Yet census data show that, by 1900, Sabato Rodia had adopted the American name Samuel and assumed the nickname Sam. He was 1.47 meters (4 feet 10 inches) tall and slender, but with powerful arms and strong hands. In the few jobs he was able to get with his brother's help, Sam built a reputation as a good, hard worker.

Family members recall that Sam left Pennsylvania after his brother Ricardo died in a mine accident, and moved to

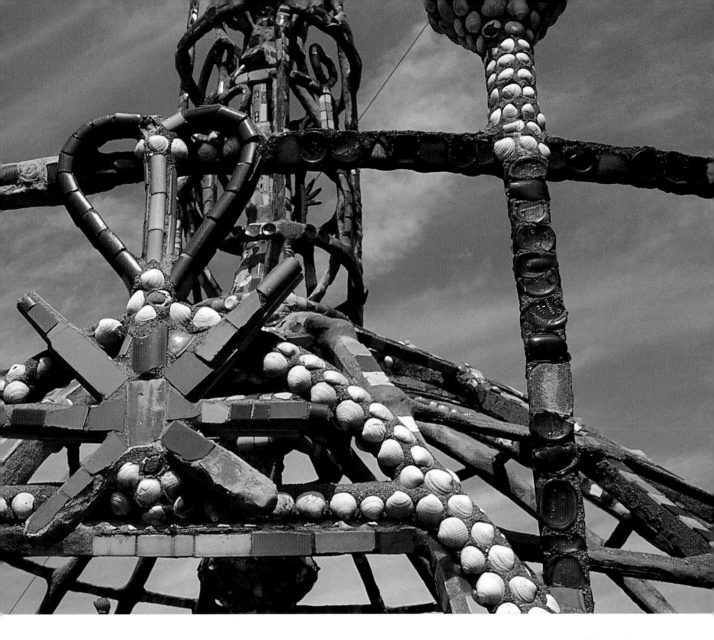

Washington State. Evidently, he went there because other Italian immigrants told him that Italians were treated more fairly on the West Coast than in Pennsylvania. Sam found work in Seattle as a laborer. He married Lucia (Lucy) Ucci in 1902, when he was twenty-three years old. The following year, a son was born who Sam named Frank, after his father, Francesco.

In 1904 or 1905, Sam and Lucy moved to Oakland, California, where a community of Italian immigrants was evolving. Sam continued working as a laborer both there and in San Francisco. Lucy gave birth to a second son, Alfred (Furi), in 1905, and later

a daughter, Bel. By working very hard, Sam saved enough money both to buy a house and to bring his sister, Angelina Rodia Colacurcio, her husband, Saverio, and their two children from Pennsylvania to nearby Martinez, California. Saverio had grown up with Sam in Italy before also making the journey to work in the coal mines.

By 1907, however, Sam was unhappy—with his life, with Lucy, and with many other things. Always prone to be rebellious and hot tempered, Sam did not hesitate to express his negative opinions to anyone, any place, any time. He was not happy with the way elected officials ran

Top of the Gazebo dome over the entranceway.

Photograph by Stephen Gill, 1997.

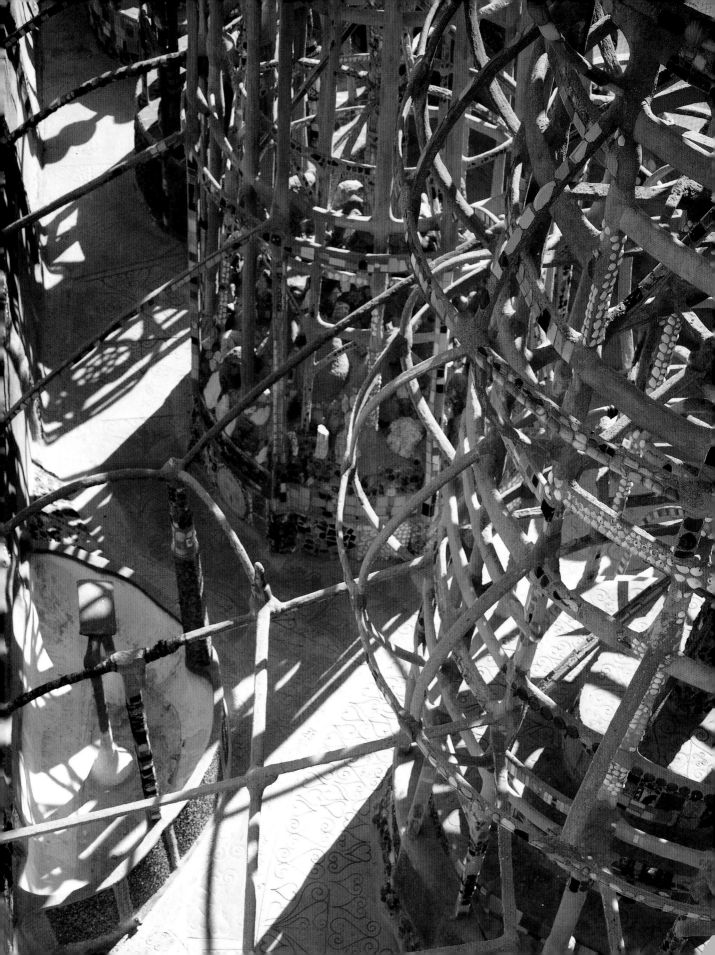

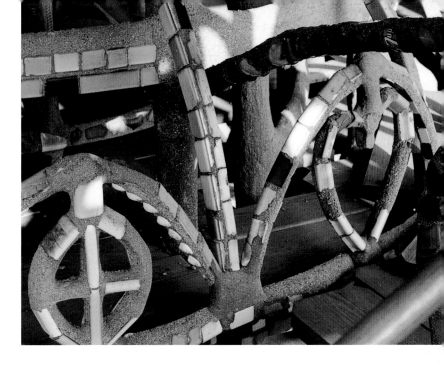

the U.S. government. He was not happy with the way mothers treated their children or with how American children acted toward their parents. He was not happy with the way police abused immigrants. He was not happy with the image afforded his favorite historical heroes, Marco Polo and Christopher Columbus among them. He was not happy with the Catholic Church.

Some family members considered Sam an anarchist and a drunkard. His daughter, Bel, had died at an early age; and he may have started his heavy drinking after her death, neglecting Lucy and the two boys. According to relatives, the marriage broke up and was finally dissolved in 1912. Sam left Oakland and disappeared before the divorce was final.

Tracking Sam's whereabouts thereafter is difficult because of confusing and contradictory reports by his relatives, some of whom claimed Sam had walked out on Lucy and the children as early as 1907. The 1910 census records, however, do not substantiate reports of an early desertion of his family. No one by the name of Lucia Rodia can be found in California, yet the census shows that on 25 April 1910, Sam lived in his own mortgaged home at 2916 Boehmer Drive, Oakland City, California, with his two sons, Frank, age seven, and Alfred, five. Sam said he was divorced, gave his name as Samuel Rodia, his age as twenty-nine (he was actually thirty-one), and his occupation as watchman. He claimed he could read but not write and that he was becoming a naturalized U.S. citizen.

Later in 1910, evidently discouraged with his life in Oakland, Sam moved to El Paso, Texas. Here he found work and, in 1917, married a Mexican woman named Benita. When they married, Benita was sixteen, Sam, thirty-eight. Sam and Benita soon moved to Long Beach, California, where Sam's surviving brother, Tony, was

Detail showing intricate, ornamented interconnecting members in the large outer rings on the West Tower.
Photograph by
Bud Goldstone, 1995.

Rodia selecting ornaments from his workbench behind his house.
Photographer unknown.
Still from The Towers, 1953.
Courtesy William Hale.

Opposite:
View looking down at the northern portion of the patio. Clockwise from left are the North Wall Fish Pond, the Center Tower, and the West Tower.
Photograph by
Marvin Rand, 1987.

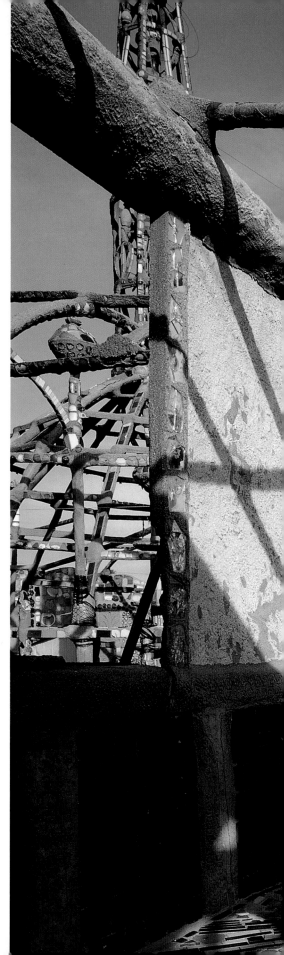

View looking east at the A Tower, center, with the house facade on the left, the South Wall on the right, and some of the connecting overheads.

Photograph by Marvin Rand, 1986.

living.[4] By now an experienced cement worker, Sam had no problem finding work with independent contractors in the Port of Long Beach.

By late 1917, Sam had begun to build small sculptures in his yard at 1216 Euclid Avenue. After work and on weekends and holidays, he built a set of five colorfully decorated, steel-reinforced and mortar-covered planters, a stationary merry-go-round, and a fish pond. The materials and techniques employed were similar to those used four years later in his majestic towers in Watts.

By 1920, Sam and Benita had moved their residence to 1204 North Redondo Avenue in Long Beach. To the census taker, he gave his name as Sam, age as thirty-five (now he was forty-one), and occupation as cement finisher. He also said that he was an alien but that he could read and write English. And he claimed to have come to the United States in 1891, not 1895, as reported in the 1910 census.

Manuel and Mercedes García, Sam's neighbors at his first Long Beach address, kept in contact with him from 1917 into the 1940s. In a 1963 interview, they said Sam and Benita separated late in 1920. Sam married Carmen, a Mexican immigrant, at the García's house the following year.[5]

By then, Sabato Rodia was ready to start building his dream. He and Carmen first found a suitable lot in Compton, south of Los Angeles, but Sam rejected it in favor of a small house with a large side yard at 1765 East 107th Street in the City of Watts, a small town between Los Angeles and Long Beach. Sam's brother Tony provided the financial help that allowed Sam and Carmen to move to Watts.

The property was situated on an inexpensive, oddly shaped, triangular lot, the last on a dead-end street. The few one-story houses on the street were small, occu-

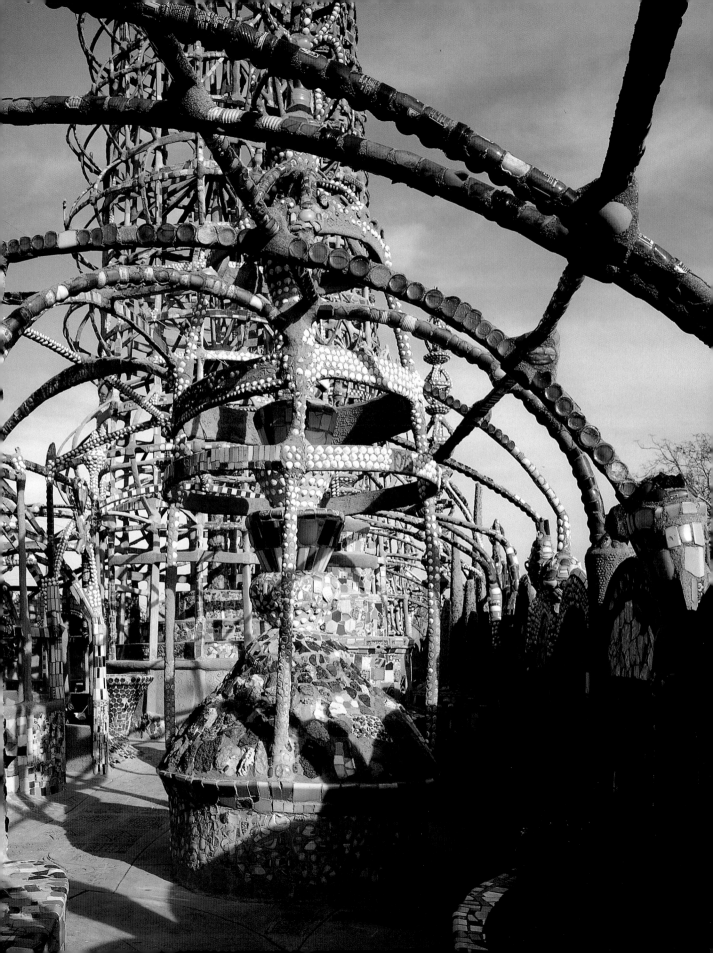

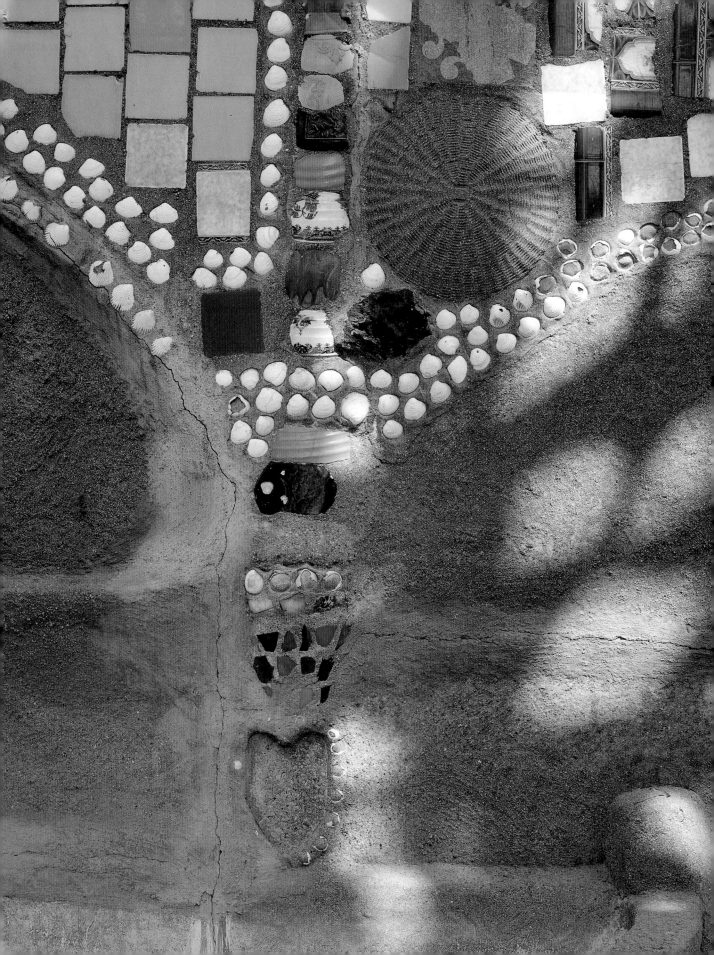

pied mainly by gardeners, laborers, and their families. Sam's lot was noisy and constantly invaded by dust and dirt blown in from every direction. Southern Pacific freight trains rumbled by three to four times a day, and a steady stream of Pacific Electric streetcars added distracting vibrations to the noise and dust seven days a week.

Two major transit lines of fifty-to-seventy-passenger Big Red Cars passed close to the lot. One line, the Santa Ana, carried forty such cars each day (almost 20,000 passengers a week), just 10 meters (30 feet) from the north side of Rodia's lot. A short block away, within clear view of the site, five other lines, running to and from Long Beach, Redondo Beach, and other cities, carried two hundred cars each day (almost 75,000 passengers a week).[6] Despite these annoying distractions, the highly visible lot in Watts was exactly where Sam wanted to create his towers, to provide his work the largest possible audience.

According to Sam, Carmen left him shortly after they moved in, taking all of his belongings, including his phonograph and prized record collection of Italian operas. Carmen's actions seem not without cause. The constant noise and dirt from the many trains, combined with Sam's obsessive attention to his sculptures every day after work and the entire weekend, were no doubt more than Carmen could bear. After Carmen left, Sam lived alone and was free to create his dream without the conflicting responsibilities of marriage. Prominently displayed in his small house was a large bulletin board, with carefully preserved pictures of himself and his towers, recording his accomplishments.

When Rodia began building his sculptures in Watts, he was forty-two years old and had lived in the United States for

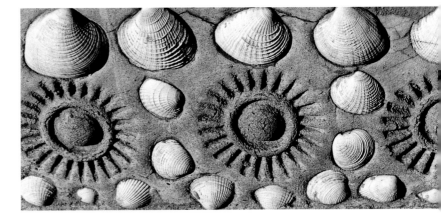

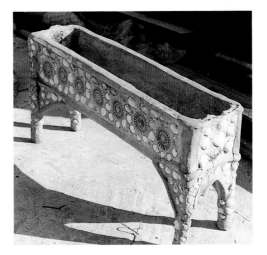

A planter box, detail shown above, made by Rodia for a neighbor, ca. 1930.

Photographs by Bud Goldstone, 1992.

Opposite: Detail of the North Wall, looking north.

Photograph by Marvin Rand, 1987.

*The Ship of Marco
Polo spires looking
southeast from
the patio floor.*

Photograph by
Seymour Rosen, ca. 1967.
Courtesy SPACES.

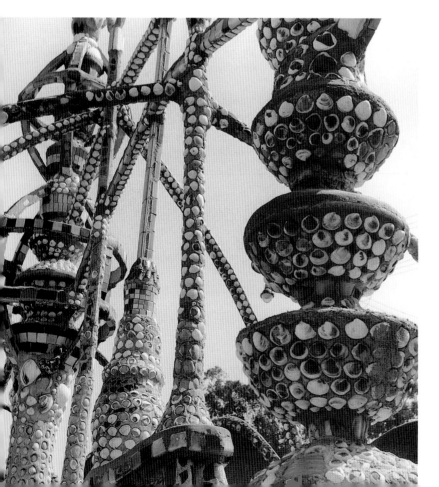

twenty-six years. He still spoke with a heavy Italian accent that made him difficult to understand. His inability to communicate, whether orally or in writing, created a barrier between himself and others who might have helped him in many ways, including the enormous task of building the towers.

Reporters, art authorities, and possible patrons turned away from him because of his incomprehensibility, his characteristic ranting against powerful institutions and certain aspects of American society, and the false information he often gave about himself and his towers. Rodia's stated purpose, often expressed to reporters, was simply, "I'm gonna do something." He explained his work and dedication with such quotes as, "This is a great country," and, "I gave up drinking," and, "I buried my wife here."

One of the earliest public mentions of the Watts Towers and Rodia appeared in the *Los Angeles Times* in 1939 and became the basis for countless magazine and newspaper articles written thereafter. In the 1939 article, in a book published in England ten years later, and in other articles published through the mid-1980s, Rodia's true name was never used. He was referred to as Simon Rodilla or Sam Rodilla or Simon Radilla or Don Simon or Sam Radilla or Sabatino Rodia or Simon Rodia or Sam Rodia. He was never called Sabato Rodia, the name given him at birth.

Even some of his neighbors continually got his name wrong. From 1917, his Long Beach neighbors, the Garcías, took to calling him Don Simon—employing the Spanish and Italian title of respect, "Don" as in "Sir"—and probably leading to the name "Simon" Rodia, the name later officially attributed to the builder of the Watts Towers.

Much of the confusion was created by Rodia himself. Along with his penchant for

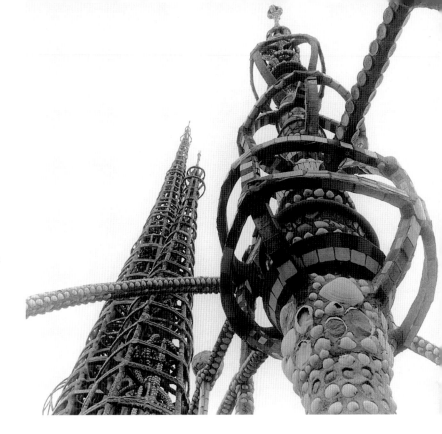

abruptly cutting off conversation when he wanted to rid himself of intruders was his unwillingness to provide straightforward and consistent answers. As in the census reports, his Social Security application of 19 March 1937 was filled with anomalies. The application was probably filled out for him by a co-worker at Taylor Tilery, a Santa Monica tile factory. The form incorrectly lists Rodia's birth date as 15 April 1886, his birthplace as Rome, his mother's last name as Rosen, and his formal name as Sam.

In an interview first published by Selden Rodman in 1952, Rodia permitted the distinguished writer to refer to him as Simon Radilla. Rodia told Rodman that he had been born in 1898, had come to the United States when he was nine years old, served in France during World War I, and been discharged from the U.S. Army in 1918.[7] Indeed, Rodia himself was the cause for erroneous information published about him in all interviews he held with writers and reporters between 1937 and 1954.

In 1948, several curious inspectors from the Los Angeles Building and Safety Department questioned Rodia at the site. They asked Rodia why he had spent so many years and so much effort to build the towers. Standing in front of the three tallest sculptures, Rodia spoke courteously to the inspectors: "I build the towers in honor of the highways of California." With a straight face, he pointed to the top of the tallest one. "I build that tower 101 feet tall, in honor of Highway 101." Pointing to the Center Tower he added, "I build that tower 99 feet tall, in honor of Highway 99." And indicating the East Tower, "I build that tower 66 feet tall, in honor of Highway 66."[8]

The inspectors duly recorded Rodia's words. Eleven years later, they were read into the record of a 1959 municipal court hearing on a demolition order from the Los Angeles Building and Safety Department.

The Watts Towers looking northwest from the base of the Ship of Marco Polo. The spires from left to right are the Center Tower, the East Tower, and the Ship.

Photograph by Seymour Rosen, ca. 1967. Courtesy SPACES.

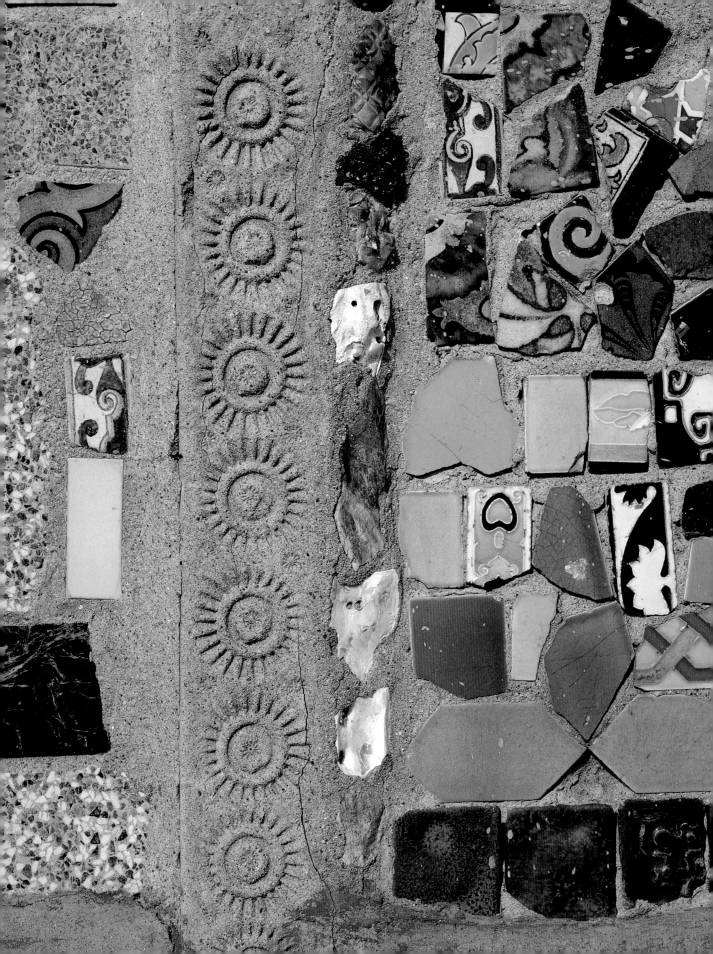

In a German magazine in the early 1950s, Rodia's answer to the question of why he built the towers was, "My wife died and I buried her under the tall tower." And to a reporter in 1952, his answer to the same question was, "Because there are nice people in this country." In an interview recorded in 1961, in Martinez, California, where he had moved after leaving Watts, his response came in a whisper, with a downcast expression, "I lost my job."[9]

In later life, Rodia continued to grouse about neglected children; women with too much makeup; politicians; how people who accomplished great things like Christopher Columbus, Marco Polo, and others, had "died in chains"; how the police should walk a beat, not drive cars, because they "couldn't catch a man with his pants open driving in a car sixty miles an hour down the street." Yet complaints like these seem altogether in character for someone whose eccentricities included walking out on his family, installing a siren in his car to use to bypass traffic jams and then burying the car next to the towers before an impending police visit, and spending thirty-four years of his life and most of his money building a nonfunctional, albeit universally acclaimed, work of art.

Charles Mingus, the great jazz musician who was born in 1922 and lived only a block from the towers, watched Sam build small portions of the sculptures and later remove and rebuild them. In Mingus's autobiography, *Beneath the Underdog*, he states that in the early 1930s, neighborhood boys brought empty bottles to a friendly Rodia, who was seen once "drinking good, red wine."[10]

In 1938 or 1939, and again in 1947, Rodia was quoted: "One day, I started building a fence round my place with tile. I find that's lots of fun; and I build the

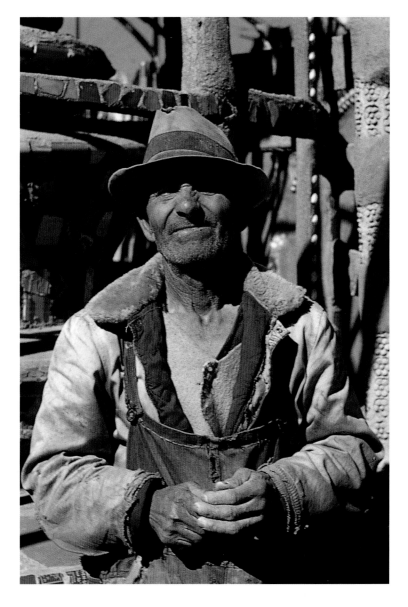

Opposite:
Detail of the South Wall, looking north, showing rocks, gear engravements, and green linoleum tiles (on left).
Photograph by Marvin Rand, 1986.

Rodia.
Photograph by Jay Weynn, ca. 1953.

HOMAGE TO SIMON RODIA

"Simon Rodia assembled Watts Towers for one sole purpose. This was to express his freedom of life. He was unaware of the towers' artistic value for the future. Rodia's honesty, pure thinking, combined with a knowledge of his craft, enabled masterful construction. The most important possession this man had was magic. He left it with the Watts Towers."
Gordon Wagner
Artist

"The old man had one magnificent thing to do and he did it and when he was finished, really finished, he'd emptied his heart and guts. It's a wonderful kind of monument to have left behind. I remember him as a very shy and antisocial man. He put his heart and soul in these towers and he was blessed with this one huge spurt of artistic blood."
Paul Coates

Rodia at the program in the auditorium at the University of California, Berkeley, October 1961.

Photographs by
Seymour Rosen, 1961.
Courtesy SPACES.

"What force could keep a man working on one project for a whole generation? Simon Rodia said it in two words: Nuestro Pueblo—Our Village, our people, our human race—the idea that one man, by using the full resources of a brilliant and controlled imagination, could create a symbol for the hungers and aspirations of all."
Max D. Gould
Treasurer of the Watts Towers Committee

"I knew he was alive, but it seemed redundant to meet him. You know the man at once through the instant reality of his towers. I would have fought for them had they been artistically atrocious. One man and determination built them and this is worth saving."
Miv Schaaf
Chairman, The Architectural Panel

"Sam Rodia's genius sprang from his heart—a heart filled with gratitude to America. His was not a passing fancy but a devotion that continued unabated for thirty-three years. His massive, colorful, symmetrical towers will endure for generations."
John Anson Ford
Member and former chairman of
the Fair Employment Practices Commission

"Simon Rodia, creator of the Watts Towers, represents that artist who, without formal training and untouched by the deadening influences of the institutional society, has given us pause with these fine constructions. Few knew he was an expert in the use of concrete, the only material that could give form to his intention. The rest was surely instinct and a great heart for his work—a perfect example of a function based on love and pride. The Rodia Towers are as pure a work of art as this country can rightly call its own."
Gabriel Kohn
Sculptor

From the *Los Angeles Free Press*, 23 July 1965.

fence so much, I forget to drink. I no kid you, honest."[11]

In the 1952 Selden Rodman interview, Sam was quoted as saying that after he had fought in World War I he wanted to work for peace. He went on to note that he did not use the radio a niece had given him for fear of hearing more about violence. Instead, he preferred to listen to classical music on a horn phonograph.[12]

In a twelve-minute documentary, *The Towers,* made in 1953 by William Hale, a graduate student at the University of Southern California located just a few miles north of the towers, Rodia is heard to say, "I had it in my mind, I'm gonna do something." When Hale pressed him further, Sam explains, "Some of the people say 'What's he doin'?' Some of the people, they think I was crazy. And some of the people say 'He's gonna do something.'"

And finally, "I did it all by myself. I never had a single helper. One thing, I couldn't hire any helper. I don't have no money. Another thing. If I hire a man, he don't know what to do. A million times, I don't know what to do myself. I would wake up all night, because this was all my own idea." Years later, Hale said he felt that Sam was getting ready to leave the towers soon after the film was made.[13]

After he abandoned them, Rodia had no contact with his first wife, Lucy, or his sons, Frank and Furi. He probably had no contact with Benita or Carmen after these marriages ended. So it is not surprising that, as far as can be determined, none of his wives or children has ever visited the towers. In 1961, Rodia's son, Frank, commented by telephone, "Yes, I am his son. But he is not my father."[14]

Rodia himself left the site in 1955, never to return. Yet since 1978, many of his relatives have come to see the towers. Among these have been Bradley Byer of

The garden planter box made by Rodia, ca. 1933, in his sister's yard in Martinez, California.

Photograph by Seymour Rosen, 1961. Courtesy SPACES.

Los Angeles, a great nephew; Gina Calicura of Pleasant Hill, California; Judy Cefalu of South Lake Tahoe, California; Sandy Rodia Reeds and Mike Rodia of Salem, Oregon; Larry Wiersum of Phoenix, Arizona, and Archie Rocco Rodia of Glendora, California, a great-great-grandson.

Sabato Rodia's Watts Towers odyssey began in 1921 and ended thirty-four years later, when he left Los Angeles and settled in the Northern California city of Martinez. His final years, from 1955 to 1965, were spent in a run-down, two-story boarding house, where he rented two small upstairs rooms. He spent his days wandering the streets of Martinez and hanging around the railroad station, talking with anyone who would take the time to listen.

On 12 July 1965 Sabato Rodia died after a short illness. He was eulogized by art lovers throughout the world. The *Los Angeles Free Press* devoted an entire issue to a compilation of comments on the man and his monument from admirers around the world.

NOTES

1. Personal interviews with Edward Landler and Brad Byer, 1983 to 1995.
2. Daniel Franklin Ward and I. Sheldon Posen. "Watts Towers and the Giglio Tradition," *Folklife Annual*. Library of Congress, 1985: 142–57.
3. Leon Whiteson. Various articles. *Los Angeles Herald Examiner*, 1985. (See Suggested Reading.)
4. Personal interview with Pete Scanlon and Manuel and Mercedes García in Long Beach, 1963.
5. Ibid.
6. *Henry Huntington and the Pacific Electric Trains*. Los Angeles: Anglo Books, 1970 and personal interviews with Howard M. Rubin, 1987 and 1996.
7. Selden Rodman. *Artists in Tune with Their World*. New York: Simon and Schuster, 1982.
8. Personal notes from Los Angeles Building and Safety Department demolition hearing for the Watts Towers, 1959.
9. Personal audio tape from meetings with Rodia in Martinez and at the University of California, Berkeley, October 1961.
10. Charles Mingus. *Beneath the Underdog: His World as Composed by Mingus*. New York: Vintage Books, a division of Random House, 1991.
11. "Dream Towers." *When Magazine*. Los Angeles, March 1947.
12. Selden Rodman. *Artists in Tune with Their World*. New York: Simon and Schuster, 1982.
13. Personal interview with William Hale, 1996.
14. Personal conversation with Frank Rodia, 1961.

View looking up through the Gazebo dome with the West Tower on the left.

Photograph by Seymour Rosen, 1959. Courtesy SPACES.

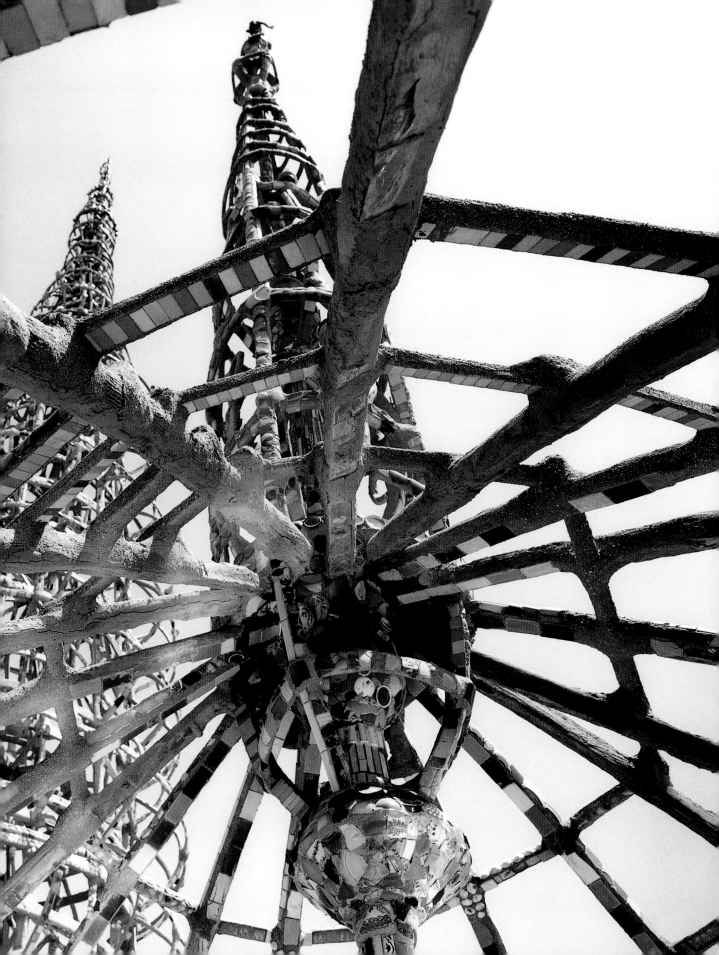

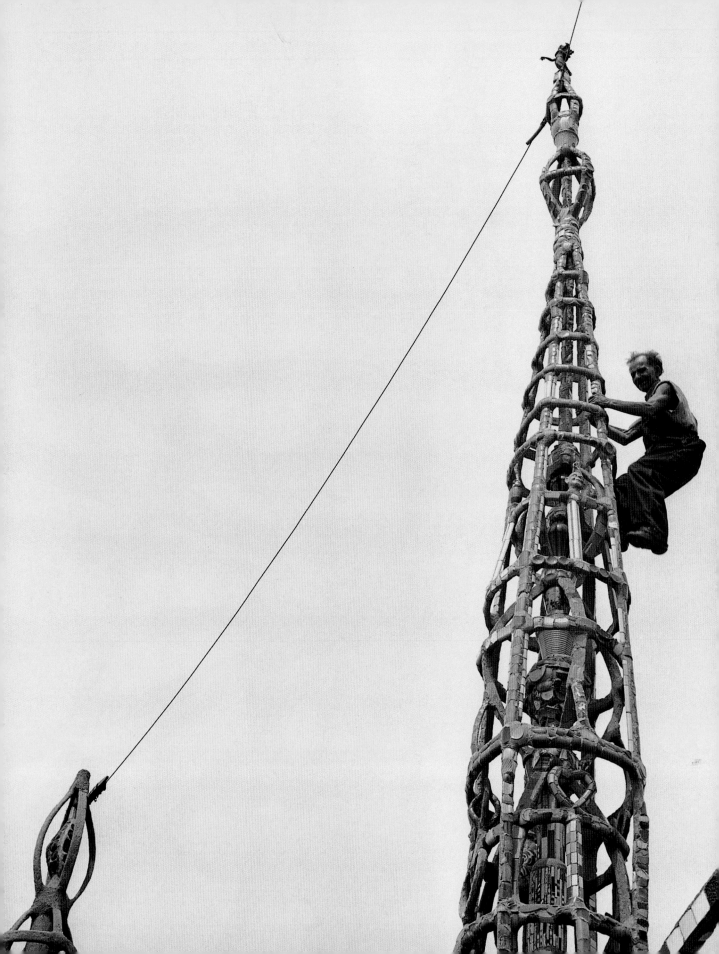

Building Techniques

No one recorded the methods and materials the artist used to create his works in Long Beach, Watts, or Martinez, California. Rodia had no drawings, specifications, permits, or plans for any of his work.

Rodia climbing the Gazebo spire, view looking north. Note the cable connecting the top of the chimney, on left, to the Gazebo, top, and off to the West Tower.

Photographer unknown, ca. 1950. Courtesy Archive Photos.

The hundreds of newspaper and magazine articles about the towers published from 1937 to 1996 barely mentioned his techniques or were vague or incorrect.

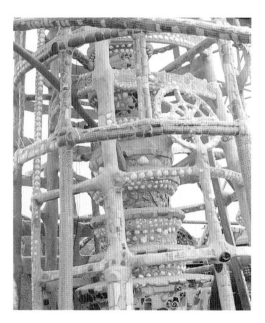

Detail showing vertical columns and bands of the lower portion of the East Tower, view looking northeast from patio floor.

Photograph by
Bud Goldstone, 1988.

*Opposite:
The Watts Towers site, view looking northwest.*

Photographer unknown,
ca. 1929. Courtesy SPACES.

Over the course of thirty-seven years, from 1959 to 1996, hundreds of visual examinations of Rodia's sculptures in Watts have been made. Key facts regarding his methods and materials were also discovered by studying early photographs, a 1939 sketch, and a 1953 film of the man and the site.

Two photographs of the Watts site, taken on the same day in 1929 by the same anonymous photographer, were found to be incorrectly labeled "1936" and "1938" respectively. An accurate, professionally drawn sketch was published in a 1939 newspaper article and again in a 1940 book accompanying an essay, "Glass Towers and Demon Rum."[1] Another series of anonymous photographs from 1950 showed up mysteriously in a New York photography archive and provided more insight into Rodia's building chronology. The documentary made in 1953 by William Hale, who coached the seventy-four-year-old Rodia to act in the film and induced him to climb one tower to the 24-meter (80-foot) level, has proven invaluable in providing an accurate visual record of what the towers looked like before Rodia left.

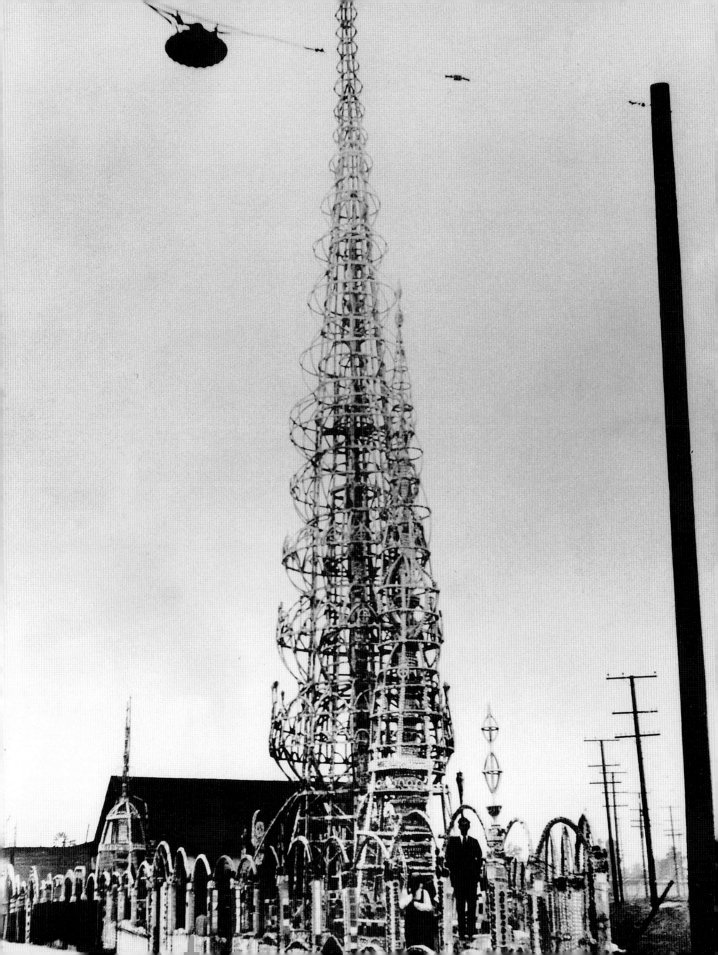

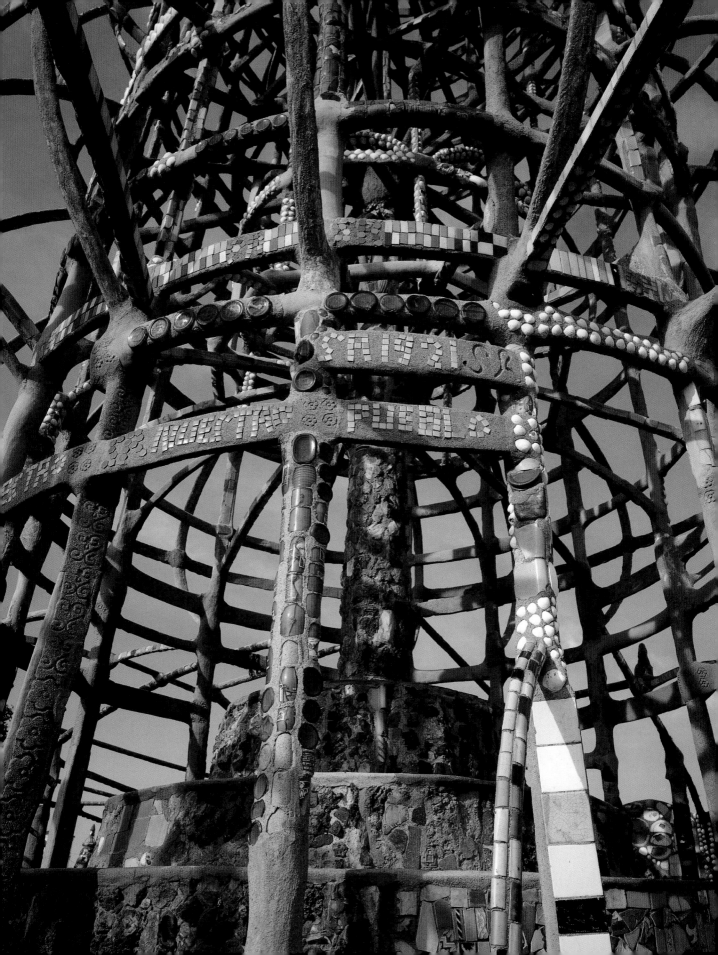

In 1963, after the City of Long Beach had demolished Rodia's former residence on Euclid Street to make way for a parking lot, some of the remains of the sculptures Rodia had built in the front yard were examined and salvaged. According to Rodia's neighbors, the García family, it had taken bulldozers just a few hours to clear away Sam's old house, where he and Benita had lived from 1917 to 1919. But Mercedes García noted that it took three days for the bulldozers to tear down Sam's garden sculptures.[2] What remained of the sculptures was still structurally sound.

Fortunately, the people who had moved into the Rodia house had taken annual family photographs grouped around the sculptures, a series of colorfully decorated, steel-reinforced, and mortar-covered planters, as well as a stationary merry-go-round. Unfortunately, the photographs are now so faded that, even if enhanced and reproduced, they would not reveal much of Rodia's methods.

It was in these garden sculptures that Rodia first used his technique of covering steel wire mesh with thin layers of cement mortar, some four years before he bought the property in Watts. He was one of the first, whether sculptor or architect, to use prestressed and thin-shell concrete as a structural building technique.

One artist who preceded Rodia in his use of mesh and mortar to create structures was Ferdinand Cheval, who built his Palais Ideal in Hauterives, France, between 1879 and 1912.[3] Cheval used mortar with sand, mesh, and stones in an early form of reinforced cement. His cement structure carries compression loads well to provide structural stability. But Rodia's much thinner reinforced cement carries both compression and tension loads very successfully, its light weight allowing for tall structures. Coincidentally, both Rodia and Cheval

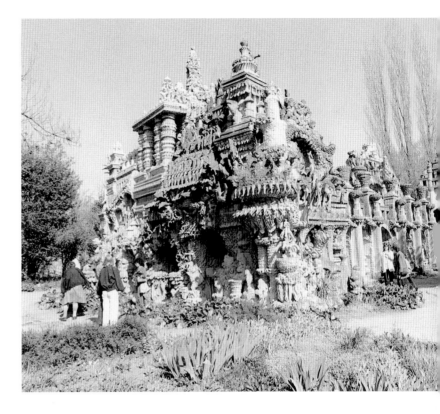

Palais Ideal,
Hauterives, France.
Photograph by
Seymour Rosen.
Courtesy SPACES.

Opposite:
The West Tower
base, view looking
northeast.
Photograph by
Marvin Rand, 1986.

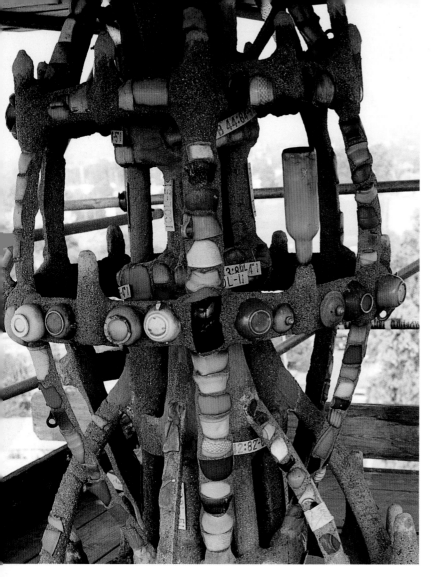

Detail showing ornamented outer rings and inner members on the West Tower.

Photograph by
Bud Goldstone, 1995.

Opposite:
View looking east from inside the North Wall with the Ship of Marco Polo, center, and the East Tower on right.

Photograph by
Marvin Rand, 1986.

worked on their major projects for the same length of time.

Buckminster Fuller credits Rodia for very early use of thin-shell concrete and also for early use of prestressed concrete in his sculptures. "I am not amazed by the fact that Rodia was an unlearned man," wrote Fuller. "I believe in intuitive intelligence and in the dynamics of genius . . . almost all great design is first intuitive design. Rodia was a master of his material, cement. [He] built the towers as a tree grows, with one ring developing after the other. The tree might become hollow, but it will not lose strength, as the surface now becomes the carrier of strength. The towers are superb."[4]

Rodia assembled most of the members of his sculptures on the ground. Without scaffolding, he then carried them up the structures along with his tools and all the cement mortar, steel, wire, mesh, and ornaments in a bucket.

The three highest towers appear even taller in comparison to the surrounding one-story houses of the neighborhood. Rodia did not name the various structures, but names have since been applied for identification purposes. The West Tower, the last built, stands 30 meters (99½ feet) tall and weighs approximately 18,000 kilos (40,000 pounds). The Center Tower is 29.5 meters (97¾) feet tall and weighs about 20,400 kilos (45,000 pounds). The East Tower, 16.76 meters (55 feet) tall, weighs some 9,500 kilos (21,000 pounds).[5]

Other main sculptures are the Gazebo, with an 11.6-meter (38-foot) tall spire; the Ship of Marco Polo, with an 8.5-meter (28-foot) spire; the 8.5-meter (28-foot) A Tower; and the 8.2-meter (27-foot) Chimney. Smaller works include the 3.96-meter (13-foot) B Tower; the 5.8-meter (19-foot) Garden Spire; the 2.44-meter-high by 30.5-meter-long (8-foot by 100-foot) North Wall; the 2.44-meter by 42-meter

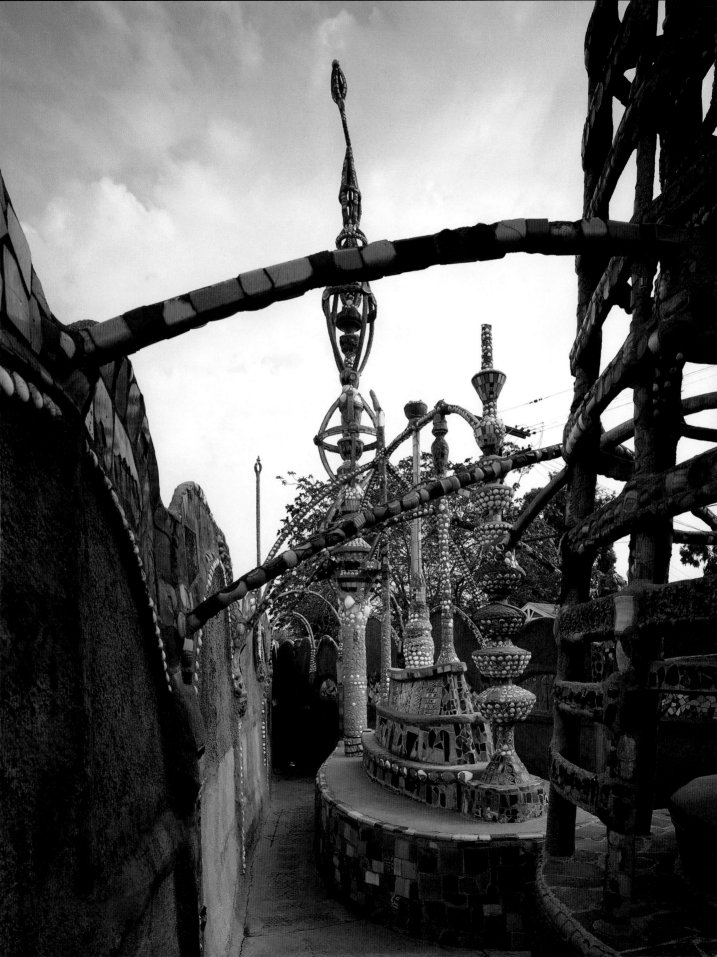

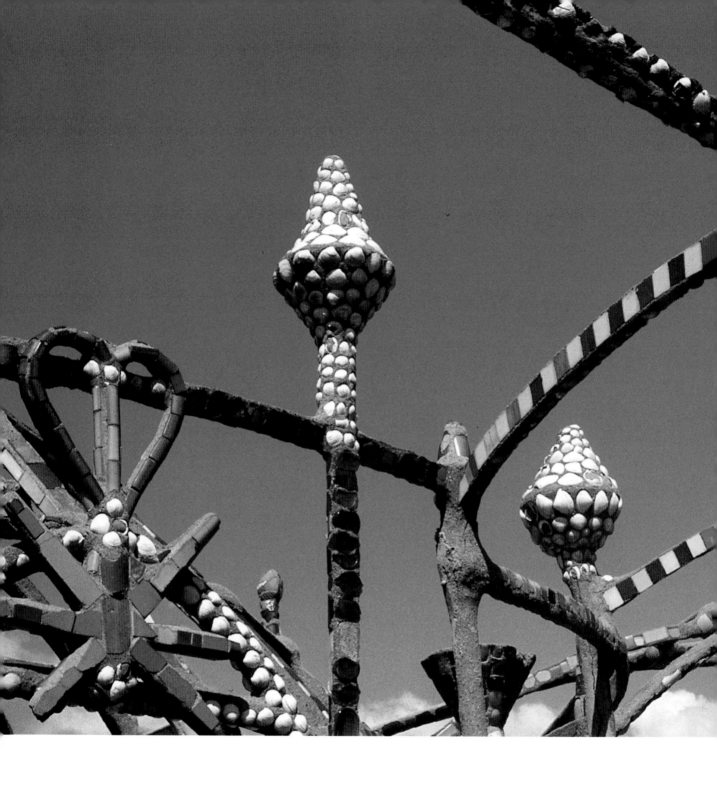

View of finials, probably shaped with scrap metal underneath, above the Gazebo entrance-way, left, near the West Tower on right.

Photograph by Justine Hill.

(8-foot by 138-foot) South Wall; the canopy over the entrance to the site through the South Wall; the house facade; more than one hundred overheads that interconnect the sculptures and the walls 3.7 meters (12 feet) above the patio; a barbecue and oven in the North Wall; and the patio floor that covers the area within the walls.

In Watts, as he had earlier in Long Beach, Rodia began by digging a trench the width of his shovel and less than 60 centimeters (2 feet) deep. He started with the Ship of Marco Polo at the easternmost apex of the triangular property and, over the next thirty-four years, worked ever closer to his house. The tallest structure, the West Tower, is approximately ten stories high, and the foundation for a ten-story building can legally be only as shallow as 7.3 meters (24 feet). The foundation for the West Tower is only 46 centimeters (18 inches) deep, completely unacceptable to Building and Safety Department inspectors. Yet this depth has proven adequate for the ten-story structure, as have the depths of foundations for all the others on the site.

Indeed, the structural adequacy of Rodia's designs has often been tested by the violent realities of nature in Southern California. The towers still stand after the Long Beach, Kern, Sylmar, Whittier, Big Bear, Landers, and Northridge earthquakes —all the major earthquakes since they were begun.

When the 1933 Long Beach earthquake struck, Rodia had already been building the towers for more than ten years. Examination of historical photographs and study of the interior structure of the towers during conservation work show that he made major changes to the structures to make them even stronger. After the Long Beach earthquake, Rodia added six outside columns and more than fifty intersecting rings on the East and Center Towers. He

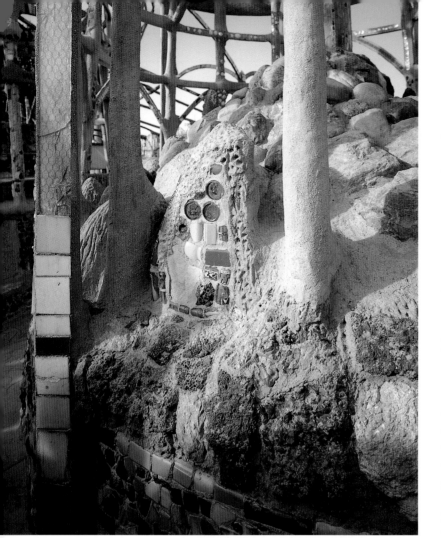

Detail of the Center Tower base, looking east.
Photograph by
Marvin Rand, 1987.

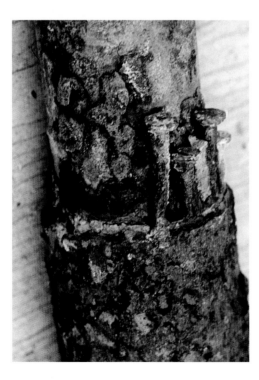

A pipe joint created by Rodia ca. 1925. The smaller diameter pipe, top, was placed inside the larger diameter pipe, below. Rodia drove nails using a hammer into the gap between the two pipes to form a tight joint. A wire or wires and a wire mesh were then tightly wound around the joint.
Photograph by
Bud Goldstone, 1995.

widened and added weight to their bases and tied the external and internal rings together with a series of decorative heart shapes that act as buttresses. When Rodia repaired or added to his original work, he often added dry pigments to the cement, creating variously colored layers readily apparent to current conservators.

Even initially, Rodia had created the tall towers with heavy bases to provide stability under wind or earthquake stress. He filled the curved, thin-shell bases with large pieces of heavy, broken concrete. He also built each tower as an integral part of the 10-centimeter (4-inch) thick patio floor, cemented completely around and to the base of the towers. In order to move the towers, wind or earthquake forces would first have to overcome the heavy weight of the base, then rip the tower out of the thick floor of the patio.

In providing safety and stability to his sculptures, Rodia didn't stop there. He also added flying-buttresslike overhead supports to each of the sculptures to help restrain them from toppling over under high winds or collapsing during severe earthquakes. He designed, ornamented, and attached more than 150 of these over-head supports, 3 to 3.6 meters (10 to 12 feet) above the patio, extending from the North and South Walls, as well as the house facade.

The foundation trenches for the sculptures were dug in a circle or an oval. Rodia then filled these trenches with cement mortar and pushed long pieces of steel vertically through the wet cement and into the earth below the trench. Four long pieces of steel became the main vertical support columns. Rodia used steel pipes, U-shaped steel channels, or T-shaped steel sections for these main supports. He usually bought but occasionally found these large steel pieces used for reinforcement inside the cement mortar.

When the mortar under the columns had set, he wrapped the upright steel tightly with wire mesh and covered the mesh with a dry, strong mortar mixture. This mixture, together with the wire mesh, hardened to become a reinforced concrete, which may be considered a form of pre-stressed concrete. Although these steel-based concrete columns serve as the main supports for the tallest sculptures, their outside diameters measure only 7.5 to 15 centimeters (3 to 6 inches).

For reinforcement inside the cylindrical bases, Rodia used steel wire mesh. When he covered the steel mesh and main supports with mortar, he created a shell 10 to 15 centimeters (4 to 6 inches) thick, and from 2.13 to 5.5 meters (7 to 18 feet) in diameter. These shells became the bases of the tall towers. Thinner shells, 2.5 to 7.5 centimeters (1 to 3 inches) thick, became the bases for Rodia's smaller sculptures. In these shells are set the lower portions of the steel reinforcements of his vertical support columns. Once the shells were completed, but before he covered them with a top or dome, Rodia placed large chunks of broken concrete inside. This increased the weight of the bases, enabling them to support the large upper portions of the sculptures.

The concrete shells Rodia used to form the outside walls of the bases are similar to shells now widely used by architects throughout the world, called thin-shell construction because the walls are indeed thin, compared to their length and width. Rodia's reinforced concrete bases and bands, 2.5 to 10 centimeters (1 to 4 inches) thick, served as thin-shelled structural members, both in his Watts Towers and in his earlier Long Beach sculptures.

The first formal architectural use of thin-shell concrete structures with wire-mesh reinforcement is often stated to have

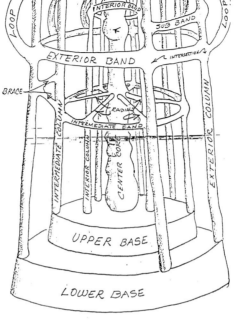

Working drawing showing structure of tower column.

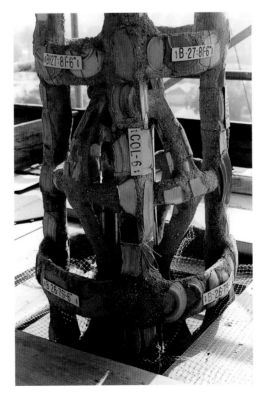

Detail showing orna-mented members in rings and on columns of the Center Tower.

Photograph by Bud Goldstone, 1995.

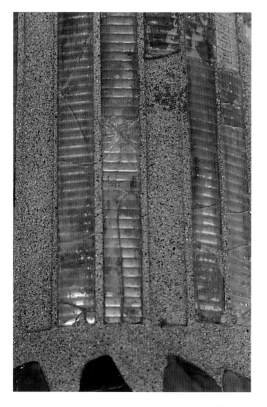

Ornamentation detail from the West Tower center column showing ribbed glass possibly from automobile lights.
Photograph by Marvin Rand, 1995.

Opposite:
A South Wall finial, formed with scrap metal underneath, with the Gazebo spire in the background.
Photograph by Justine Hill.

Horizontal band detail showing glass electrical wire insulator.
Photograph by Marvin Rand, 1995.

Seashell panel detail.
Photograph by Marvin Rand, 1995.

occurred in 1922, for the Carl Zeiss Optical works in Jena, Germany.[6] Rodia's Long Beach structures preceded this by five years.

After careful consideration, Rodia selected ornaments and designs for the cement mortar covers of the thousands of members forming his seventeen works. He used a mosaic technique known as *pique assiette,* much like that employed by the French artist, Raymond Isidore, who covered his Chartres house and yard with broken crockery.[7] In Watts, Rodia also created imprints and embedded ornaments in 1,394 square meters (15,000 square feet) of cement surfaces.[8] For the imprints to set and the ornaments to bond properly, Rodia had to maintain precise control of his medium. If the cement mortar were too dry or too wet, the imprint would disappear, the ornament fall off.

Rodia pressed into the mortar some 11,000 pieces of whole and broken pottery; 15,000 glazed tiles; 6,000 pieces of colored bottle glass; dozens of mirrors; 10,000 seashells, abalone shells, and clamshells; hundreds of rocks, large and small; pieces of marble, linoleum, and telephone-line insulators; and two grinding wheels (in the base of the Garden Spire).[9] He broke and cut much of the glass and embedded it as shards over large areas. He kept a fire going in the back of his property, where he melted some pieces of glass and embedded them as free-form shapes.

He also used many other items to strengthen his cement mortar: a 20-centimeter (8-inch) diameter, corrugated water pipe; a bicycle's front-wheel post; railroad spikes (in the North Wall); water buckets (at the bottom of wall-post footings in the North Wall); and railroad ties as wall posts.

In the front entrance on 107th Street, over the mailboxes, Rodia carefully placed

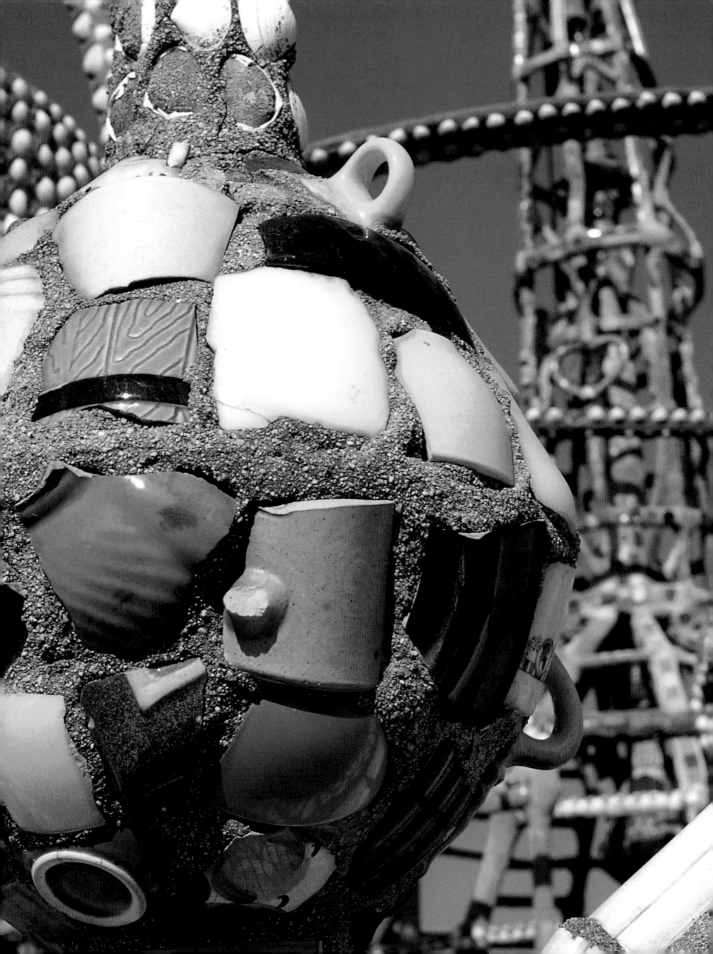

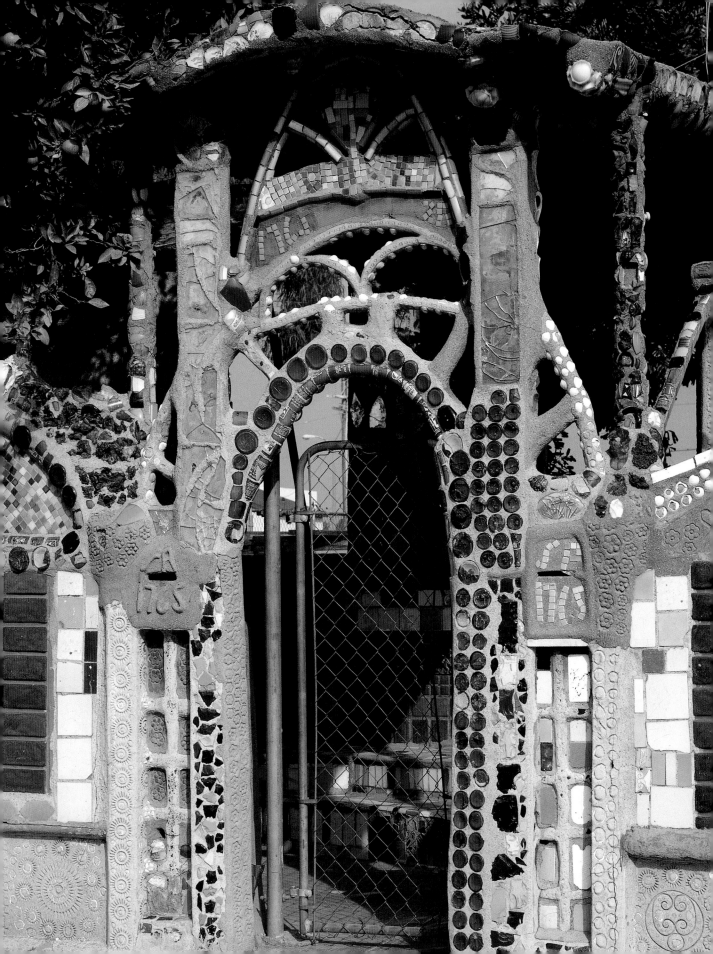

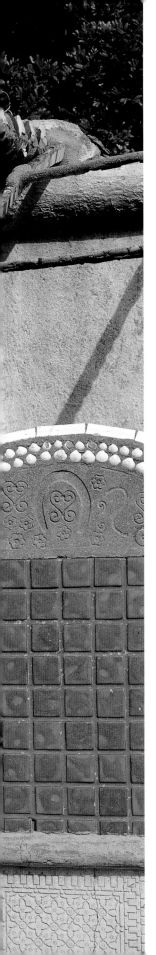

five steel rib supports made from airplane wings for reinforcement, then covered them with steel mesh and cement mortar to achieve the shape he sought for that important part of his sculpture. The main reinforcements in the slender supporting legs of the tallest towers are preexisting steel shapes: 7.5-centimeter (3-inch) diameter pipes, 5- by 5-centimeter (2- by 2-inch) angles, 7.5-centimeter (3-inch) T sections, and rods and channels of different sizes. Rodia used various kitchen pots and pans and at least two kitchen colanders as forms to build his finials on the Gazebo, tall towers, and other sculptures. For one finial, he used a bowling ball.

Despite seventy years' exposure to sun, rain, and wind; as well as recurrent earthquakes; and, for a short time after Rodia left Watts, vandalism, the great majority of these ornaments are still in place.

Rodia's ingenuity solved problems that might easily have overwhelmed anyone else, certainly stopped others from attempting to create even one 30-meter (99-foot) sculptured tower, let alone a series of seventeen sculptures of various heights. He had only very simple tools and equipment. In William Hale's film, Rodia is shown using the nearby railroad tracks for leverage to bend his steel reinforcements into the desired shapes.

He also had to deal with his age and the limited time available to him. When Rodia began his work in Watts at the age of forty-two, he had no patron or other sources of financial help. He had to hold a full-time job, laboring eight hours a day, in addition to working on the monument.

He built the towers by hand, alone, without machine tools, without nails, without scaffolding, without written plans, and with no client to absorb the costs. He had no drill and used no bolts to hold together pieces of the steel he used. He could not

Gas fitter's pliers used by Rodia, ca. 1930. Gift from Brad Byer, collection of Arloa and Bud Goldstone.
Photograph by Bud Goldstone.

Opposite:
The front entrance to the Watts Towers site in the South Wall, and the canopy overhead.
Photograph by Marvin Rand, 1986.

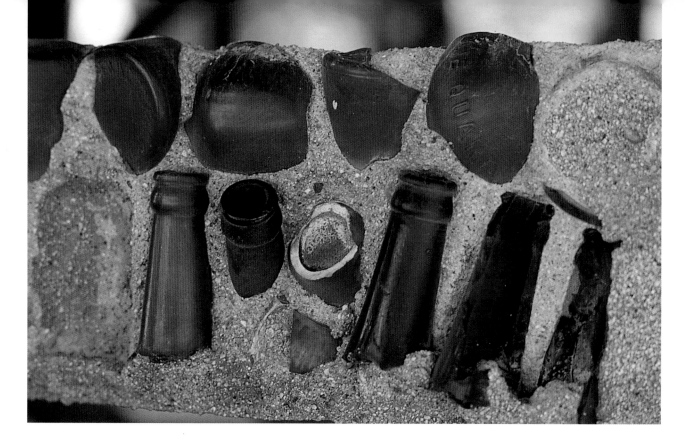

*Detail of a
horizontal band.*
Photograph by
Marvin Rand, 1995.

*Opposite:
View looking east
with the Fish Pond,
left foreground, the
North Wall, left
background, and
the Center Tower,
right center. Some
of the overheads
connecting the North
Wall with the tall
sculptures and details
of the patio floor
can be seen.*
Photograph by
Marvin Rand, 1986.

weld pieces of steel; he had no welding torch. He also had to create several sculptures simultaneously, working in one area while waiting for the mortar in another to harden so that it could support his weight. Nor did Rodia have specific plans in his head. As he said in William Hale's film, all he knew was that he wanted to do something big.

In 1961, Rodia was shown pictures of Antonio Gaudí's celebrated church of La Sagrada Familia, in Barcelona, Spain. When questioned if he had ever before seen Gaudí's work, Rodia simply asked, "Did he have helpers?" When told that Gaudí had employed a crew of workmen to build his designs, Rodia crowed, "I did it myself!"[10]

NOTES

1. Drawing by Charles H. Owens in Joseph Seewerker, *Nuestro Pueblo: Los Angeles, City of Romance.* New York: Houghton Mifflin, 1940 and in the *Los Angeles Times*, 28 April 1939.

2. Personal interview with Pete Scanlon and Manuel and Mercedes García in Long Beach, 1963.

3. Roger Cardinal. *Outsider Art.* New York: Praeger, 1972.

4. R. Buckminster Fuller in committee minutes, 1965.

5. Calculations performed in 1995 by the author and personnel assigned by the City of Los Angeles Cultural Affairs Department for the Watts Towers Conservation Program.

6. Source Darryl Parker, 29 April 1996.

7. Author's observations in Chartres, 1992.

8. Inspections performed by the author and personnel assigned by the City of Los Angeles Cultural Affairs Department for the Watts Towers Conservation Program.

9. Author's observation, ca. 1959.

10. Conversation with Rodia and author at the University of California, Berkeley, October 1961.

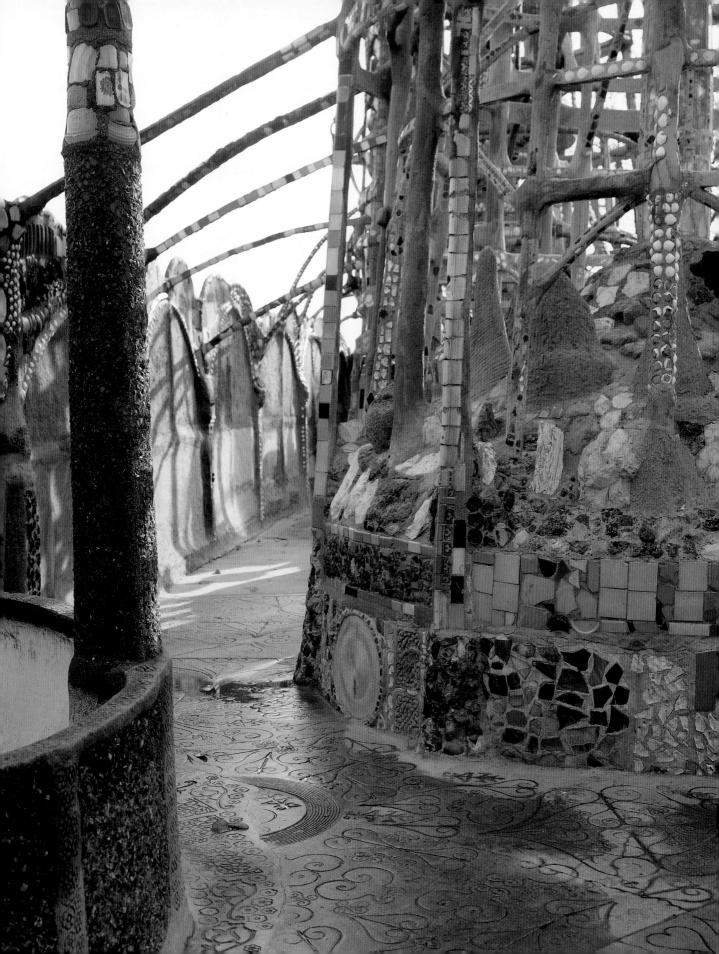

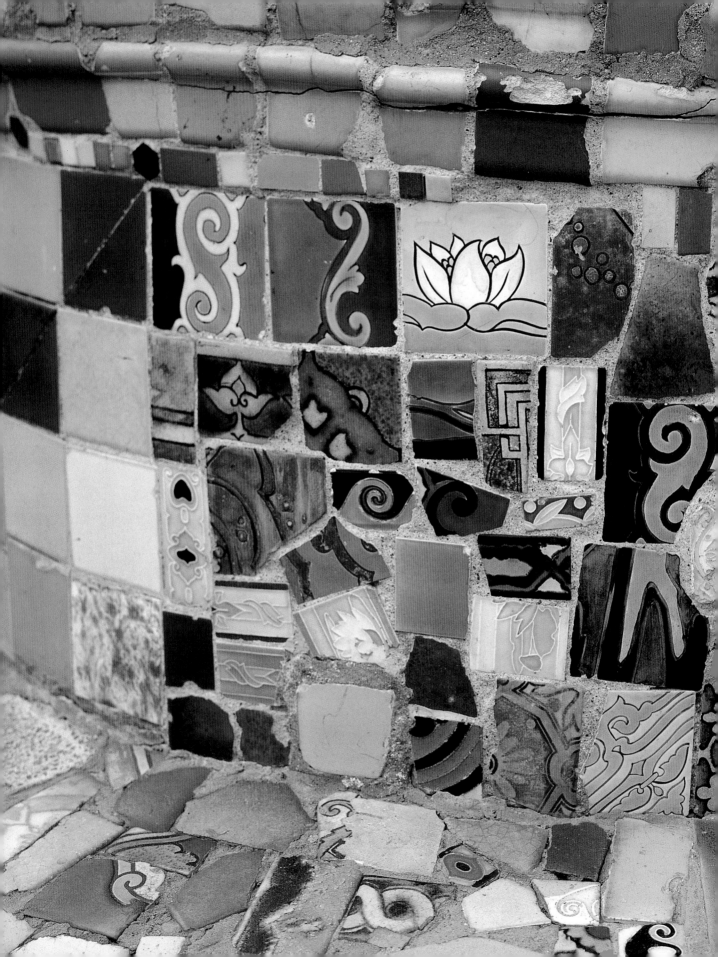

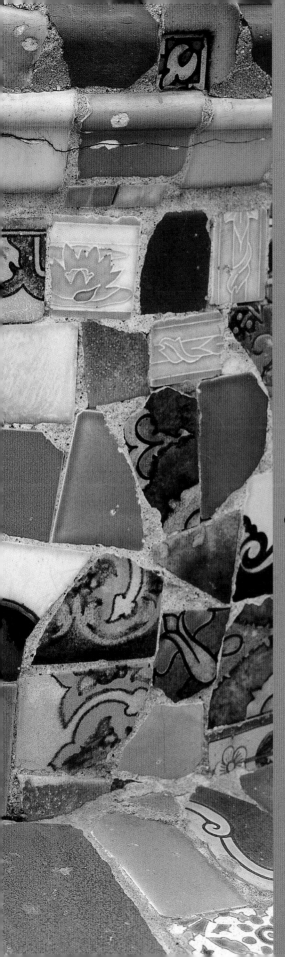

Adorning the Towers

To many who have discovered the Watts Towers, they are one of the great pleasures of Los Angeles. Delight in finding what may well be considered one of the world's only "above-ground, miniarchaeological digs" seems endless.

Looking east at the ornamentation at the base of the B Tower, possibly Gladding and McBean, American Encaustic, or Malibu tiles.
Photograph by
Marvin Rand, 1987.

The objects and materials that Rodia embedded in his mortar were all carefully selected from available sources, in other words, from wherever he happened to be at the time.

Bottles joined by steel rod and wires near the top of the West Tower.
Photograph by
Bud Goldstone, 1995.

Opposite:
Basket engravements in a tower base and heart-shaped, bent-wire, rug-beater engravements in the patio floor.
Photograph by
Marvin Rand, 1986.

Many are important as objects themselves, independent of their role as decorative elements of the towers. Rodia did not consciously set out to create a visual history of Californian, and American, material culture and decorative arts of the first half of the twentieth century, yet he accomplished precisely that. His meticulous collection and use of everyday discards has made the Watts Towers a rich repository of elements that have played a part in the life of almost every American between at least 1900 and 1950. Many of these items are now found in antique shops, galleries, and the permanent collections of museums.

Rodia used broken dishes, tiles, pottery, glass, mirrors, rocks, seashells, cooking utensils, wrought iron, scrap steel, even linoleum. The tiles and pottery are representative of such varied twentieth-century American decorative styles as Craftsman and Spanish Colonial Revival. The glass, usually fragments of beverage bottles, is predominantly emerald green from 7-Up and Canada Dry Ginger Ale, cobalt blue from Phillips Milk of Magnesia, and amber brown from wine, beer, and Clorox bottles.

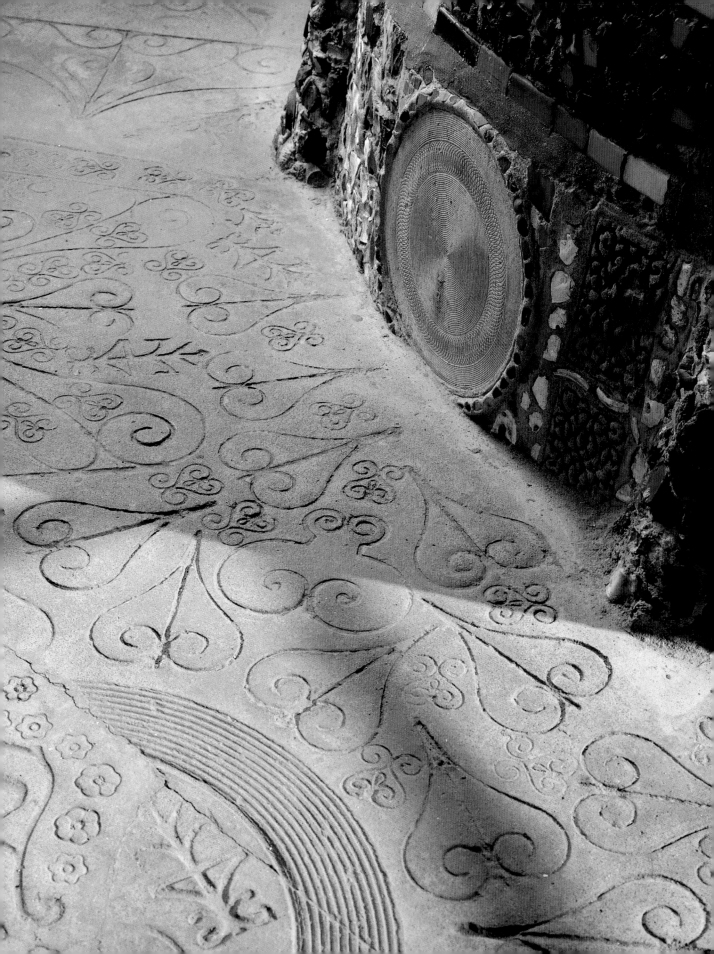

*Flamingo fireplace-
inset tile manufac-
tured by Cal-Co,
ca. 1910, on Rodia's
house facade.*

Photograph by Arloa Paquin
Goldstone, 1989.

*South Wall detail,
view looking north,
showing an inverted
Batchelder "Viking
Ship" tile, ca. 1915. An
identical tile is in the
permanent collection
of the Smithsonian
Institution.*

Photograph by Arloa Paquin
Goldstone, 1989.

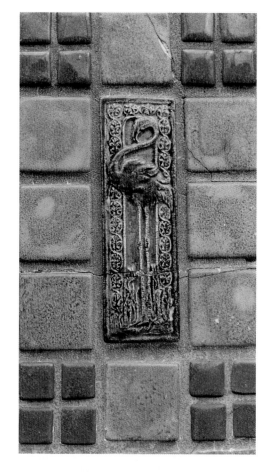

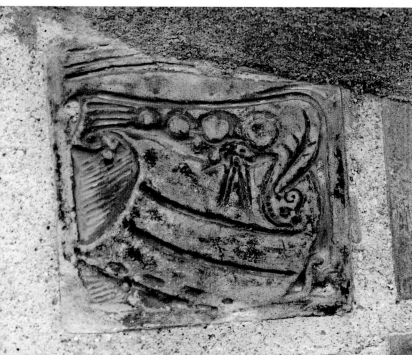

None of the glass is clear, such as was used in Coca Cola bottles of that era.

To identify specific manufacturers for many of the tiles is difficult, because they were mass produced by several companies throughout Southern California, and designs were similar. As decorative tastes evolved, manufacturers responded by producing whatever pattern was popular at the time.

Rodia used tiles of many types, but at least one tile on the West Tower base was made at Malibu Potteries in Malibu, California.[1] The firm was in business only from 1926 to 1932, selling its products through a showroom and warehouse on Larchmont Boulevard in Hollywood. Even though the company was short-lived, it produced many tiles still found in homes and other structures built in Southern California during the late 1920s and early 1930s. Malibu Potteries produced a full line of tile for almost every architectural purpose, whether interior or exterior. Polychromatic, primarily abstract and geometric in design, the Malibu tiles are distinguished by their replication of European hand-decorated tiles known as Saracen or Moorish.

Malibu Potteries was founded in 1926 by May K. Rindge, who hired Rufus Keeler to manage the company. Other tiles in the Watts Towers were produced by Keeler himself at his South Gate Cal-Co tile company, which he owned and operated before moving to the Malibu firm.[2]

A few portions of the towers are decorated with tiles from the Batchelder Tile Company, equally prominent as Malibu Potteries in the history of decorative arts in Southern California. The Batchelder Tile Company—later known as Batchelder-Wilson, then Gladding, McBean and Company—was originally founded in 1909 in Pasadena by Ernest A. Batchelder.[3]

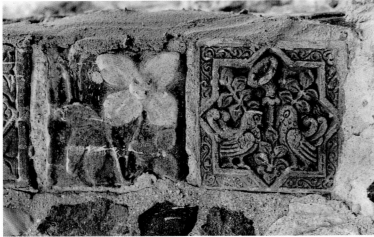

The base of the West Tower showing a Malibu tile of an inverted pine cone, ca. 1928.

Photograph by
Bud Goldstone, 1992.

A Center Tower post detail, looking northeast, showing Batchelder tiles.

Photograph by Arloa Paquin
Goldstone, 1989.

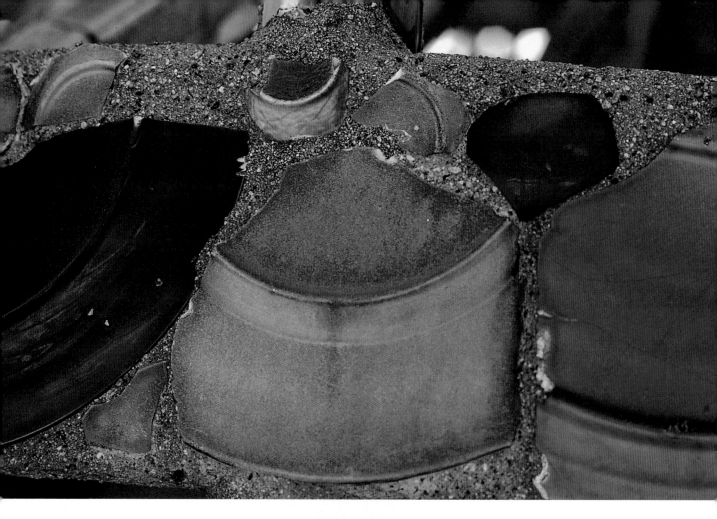

Detail of ornaments, possibly Metlox, Vernon, or Bauer, on a horizontal band.

Photograph by
Marvin Rand, 1995.

Blue Noxema jar bottom, pink ceramic cup, and green pottery base, all set into cement mortar.

Photographs by
Bud Goldstone, 1995.

The early Batchelder tiles found in the front wall of the towers differ stylistically from the Malibu tiles; they are of the Craftsman Movement and employ a softer, more somber palette. One of these earlier tiles, embedded in the lower front wall and portraying a Viking ship, can also be found in the permanent collection of the Smithsonian Institution.[4] Given their prevalence in the market, it seems likely that tiles manufactured by the largest Southern California tile company, Gladding-McBean, later called Franciscan, are also represented in the towers.

Artist Margaret Curtis Smith recalls riding to work with Rodia in 1936.[5] At the time, Smith was employed as a designer by the Taylor Tilery in Santa Monica; Rodia by the same company as a laborer. She has not been able to identify positively any Taylor Tilery pieces in the towers. Given Rodia's

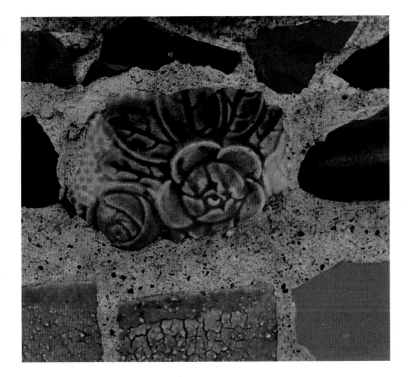

*Roseville Rozane
Ware flower bowl,
ca. 1917, on the base
of the East Tower.*
Photograph by Arloa Paquin
Goldstone, 1987.

*Pottery in a top panel
of the South Wall,
view looking north.*
Photograph by Arloa Paquin
Goldstone, 1989.

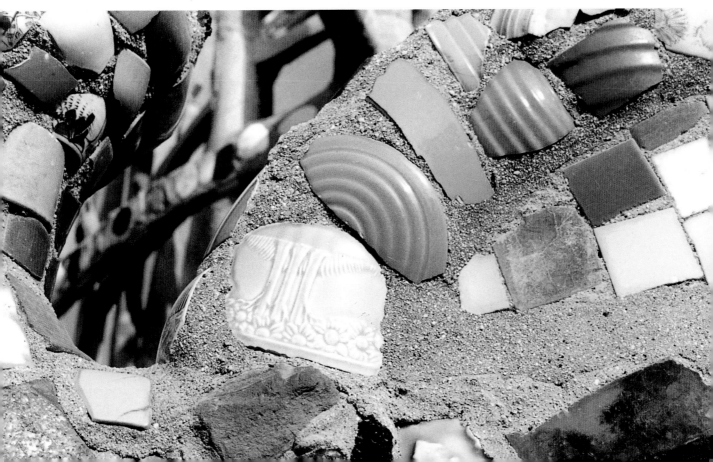

Rug-beater and wrought iron finial engravements in the patio floor.

Photograph by
Seymour Rosen, 1965.
Courtesy SPACES.

Wrought iron gate and heating register engravements in the patio floor.

Photograph by
Seymour Rosen, 1965.
Courtesy SPACES.

Opposite:
Looking northeast at the Gazebo center column showing a hand-painted Canton Ware plate from the mid-nineteenth century.

Photograph by
Marvin Rand, 1995.

easy access to the Taylor products, however, Smith believes Rodia must have used some.

Along with the tiles and other decorative elements found in the towers are many examples of household items produced in Southern California and elsewhere in the United States. Two of the brands predominantly represented are Fiesta and Harlequin tableware, both produced by the Homer A. Laughlin Company, which still operates plants in New Jersey and Ohio.[6]

During the 1920s and 1930s, Laughlin-made tableware was popular in most American households as "everyday" dishes; and it was frequently offered as a premium with purchases of cereal or soap, as well as at movie theaters. Both Fiesta and Harlequin ware are undecorated and monochromatic, usually in simple, strong colors, such as blue, yellow, orange, or turquoise. Harlequin ware was the less expensive of the two and can be distinguished from Fiesta by its more angular, geometric designs.

Locally produced tableware that Rodia used (in similarly bright, monochromatic colors) was made by J. A. Bauer and Company of Los Angeles (1890–1958). Vernon Kilns, whose colors tend more to pastels and pure white, is also represented in the towers. Metlox tableware, still in production today in many of its original maroons, blues, and greens, was sometimes used. Catalina pottery is also likely to be represented in the sculptures.[7]

The oldest piece of pottery, actually porcelain, is found in the center support of the dome-shaped Gazebo sculpture just east of Rodia's house. It is a Canton Ware plate, with the rim completely broken away. Hand-painted Canton Ware was mass produced in China for English and American export markets during the mid-nineteenth

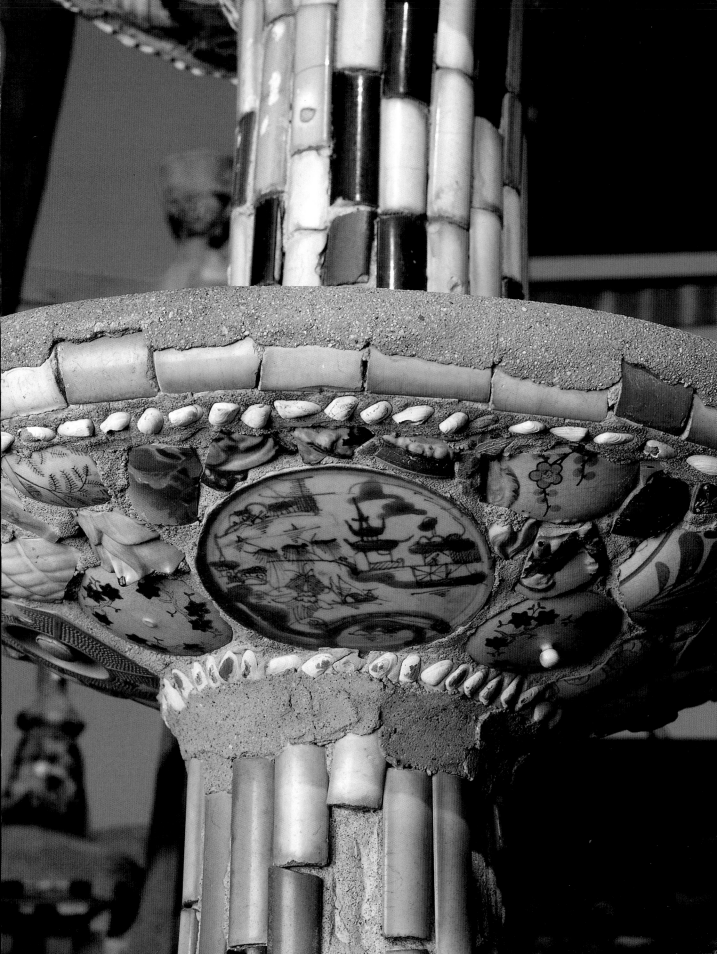

century.[8] The cheapest form of china produced for export, it was wrapped in straw and used as ballast in ships transporting more expensive cargo to overseas markets. In the strictest sense, Canton Ware is identified by a particular border design of dash (rain) and scallop (clouds), just inside the blue edge of the rim. The rim of such a platter is embedded in the North Wall.

Many generic types of pottery, porcelain, and glassware are also present in the towers. Several examples of Japanese pottery and porcelain can be found, salvaged from the trash of the numerous truck farms in the area before World War II. In addition to the green, blue, and amber bottles, a few examples of iridescent American Depression glass are evident. But whether he was using a brand-name plate or an unmarked flowerpot or vase, Rodia generally kept to a palette of bright colors.

Rodia used common household items to create patterns and designs in the cement mortar floors and walls surrounding the towers. One of his favorites was the back of the bent-wire "ice cream chair" popular in the soda shops and cafés of the early twentieth century. The top half of wire rug-beaters, several sizes of scallop-edged faucet handles, various gears from castoff machinery, wrought iron gates and grills from heat registers, baskets, cooking utensils, and finials from drapery rods found their way into his sculpture. Even his tools are imprinted in the concrete in various places.

Rodia would pour mortar into a cast-iron, corn-bread baking pan, extract the mortar, and embed the corn-shaped mortar into the towers after the mortar hardened. Pieces of slag from iron foundries in the area were similarly used to adorn his sculptures. He implanted melted glass, as well as a variety of rocks that do not occur naturally in Southern California. Pieces of

Rodia holding a cast for a North Wall panel.
Photographer unknown, 1950. Courtesy Archive Photos.

Note that the bas-relief wheat sheaf panel appears convex in this North Wall panel detail.
Photograph by Marvin Rand, 1987.

Opposite: A South Wall panel detail showing engravements and pigmented mortar.
Photograph by Marvin Rand, 1987.

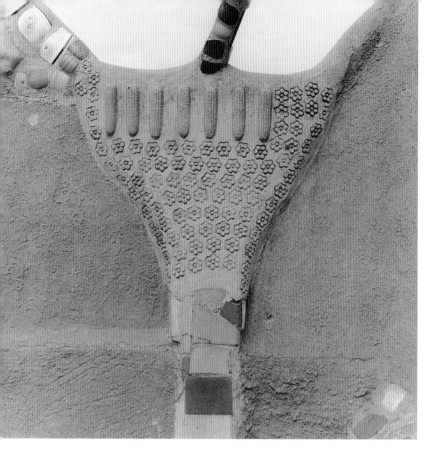

Corncob decorations in the North Wall, looking north. They were shaped by pouring mortar into a cast-iron corn-bread baker, then removed and inserted into the wall mortar.

Photograph by Seymour Rosen, 1965. Courtesy SPACES.

Opposite: Looking west at the cast-metal, headless statue on top of the Gazebo spire.

Photograph by Marvin Rand, 1995.

a highly annealed architectural glass, popular in the 1930s and 1940s, also served as decorations.

Part of what distinguishes the towers from more common folk-art sculptures is Rodia's innate aesthetic sense of just what to do with all of this eclectic ephemera. For example, even though many of the impressions he made in the concrete are heart-shaped, Rodia never used the design in a cloying or sentimental way. He knew intuitively what colors to choose and where to place them so they would play off each other beautifully and create unexpected juxtapositions. His mastery of texture was demonstrated in each choice of broken tiles, seashells, or rocks.

Perhaps Rodia's childhood in the colorful ambiance of a southern Mediterranean culture helped him to know what decorative elements would show best in a similar climate. His passion for chromatic brilliance is evident everywhere. Vivid blues and greens abound. For the light of Los Angeles, Rodia's rejection of the pallid hue

of Coca Cola bottles in favor of brightly colored glass was precisely the right choice. His blues and greens boldly reflect the intense glare of the Southern California summer sun. On a drab winter day, Rodia's instinctive selections prove even more appealing.

NOTES

1. Meeting at the towers between the authors and Toni and Tom Doyle from the Adamson House, Malibu, California, ca. 1993.
2. Personal interview with Brian Kaiser, owner of the Rufus Keeler home in South Gate, California.
3. *Batchelder Tiles: A Catalog of Hand Made Tiles.* Los Angeles, 1923.
4. R. and T. Kovel. *The Kovels' Collector's Guide to American Art Pottery.* New York: Crown Publishers, Inc., 1974.
5. Personal interview with Margaret Curtis Smith, artist and former employee of Taylor Tilery, October 1992.
6. B. and S. Huxford. *The Collector's Encyclopedia of Fiesta.* Paducah, Kentucky: Collector Books, 1992.
7. J. Chipman. *The Collector's Encyclopedia of California Pottery.* Paducah, Kentucky: Collector Books, 1992.
8. H. Peter and N. Schiffer. *Chinese Export Porcelain: Standard Patterns from 1780 to 1880.* Exton, Pennsylvania: Schiffer Publishing, 1975.

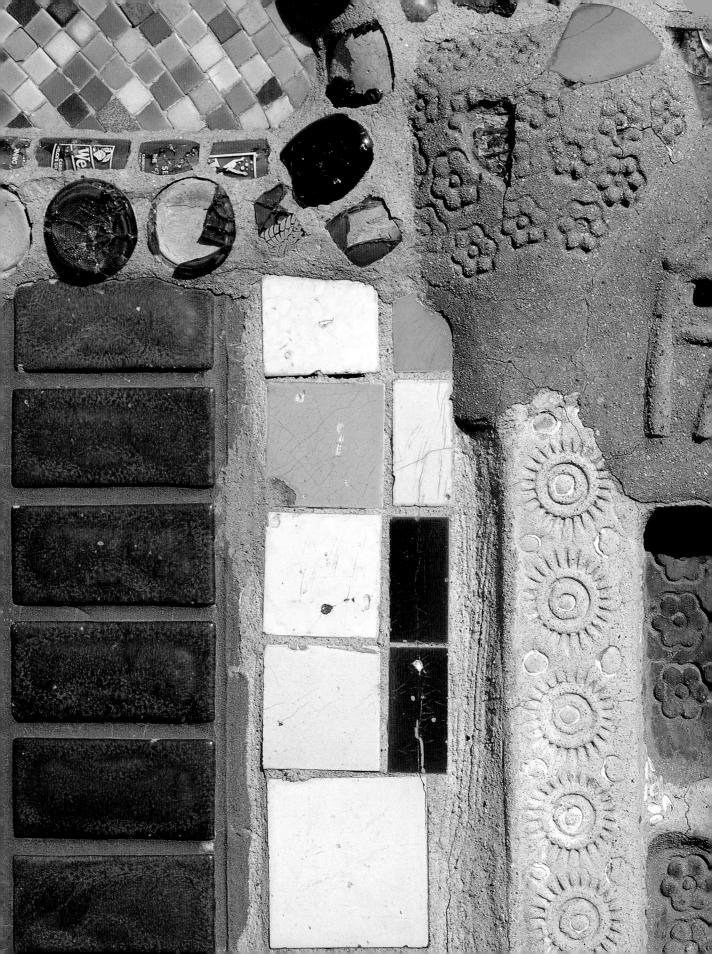

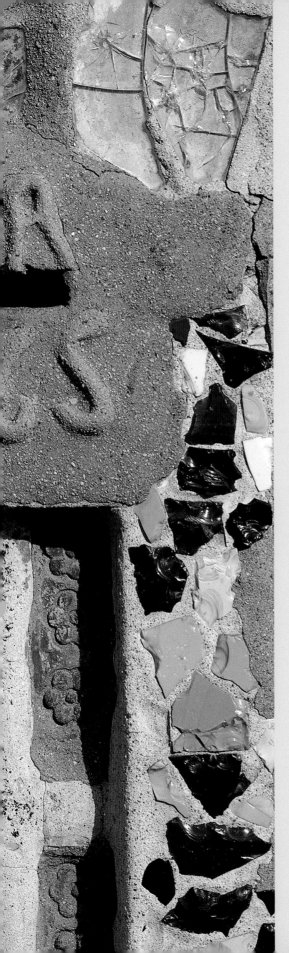

Watts

THE JEWEL

**A jewel was mine.
I lost it in the
Slimy, filthy gutters
of neglect.**

 **Now I wander
 Aimlessly, searching.**

**Finding it, I vow
To make it brighter
Than all others.**

**Guadalupe de Saavedra
Watts Writers Workshop
Watts, California, 1967**

*Detail of the mail-
box slot in the
South Wall, west
of the entranceway.*
*Photograph by
Marvin Rand, 1987.*

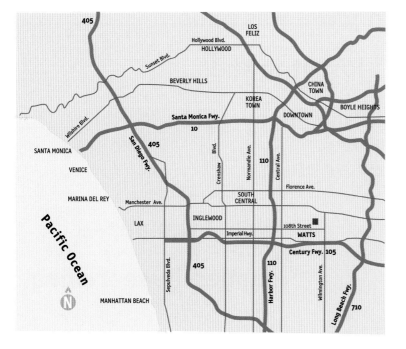

■ *Site of the*
 Watts Towers.

Opposite:
An aerial view, look-
ing west, of the Watts
section of Los Angeles,
in the early afternoon.
The Watts Towers,
center, are to the right
of 107th Street, which
dead ends at the prop-
erty line.

Photograph by Fairchild
Photo, 12 March 1950.
Courtesy University of
California, Los Angeles,
Department of Geography.

On Friday, 13 August 1965, the Watts rebellion erupted.

Via television, millions of Americans decided that the Watts area of Los Angeles was not the place to be. What they saw was rage and violence. Many failed to understand that these were symptoms of deep social problems that had been festering for many years. Fortunately, some did realize this essential truth and went on to discover the "jewels" of Watts.

From its earliest days, Watts had generally been isolated, neglected, and ridiculed. It was originally part of a small Spanish land grant, Rancho Tajuata. During the building boom of the 1880s, Pasadena developer Charles H. Watts purchased a portion of what remained of the ranch. In 1869, the first railroad line in Los Angeles County, the Los Angeles and San Pedro, from downtown L.A. to the harbor, ran through what would later become Watts.

The Pacific Electric Railway established its Long Beach branch in 1902 and determined that the area would become Watts Junction, with a line branching off to Santa Ana and another to the South Bay. The Watts Depot—now a City of Los Angeles Cultural Heritage Monument and listed on the National Register of Historic Places—still serves as a stop for the new Metro Blue Line to Long Beach.

A switching building of the Pacific Electric Red Car, ca. 1959, view from the west. "Watts Tower," one of only four on the extensive Los Angeles streetcar system, was built near the intersection of 103rd Street and Graham. The Red Car system operated from 1904 until the early 1960s.

Photograph by
Marvin Rand, 1959.

When the old depot was built at 103rd Street and Graham, subdivision fever struck the area. Real estate developers carved the land into small tracts that would appeal to working men and their families. The 21 August 1904 issue of the *Los Angeles Examiner* advertised Watts Junction as the "Home of the Workingmen." A lot could be bought for a dollar down and a dollar a week. In 1906, with a population of 1,400, Watts Junction petitioned for cityhood. The new status was granted in 1907, and Watts remained an independent city until its annexation by Los Angeles in 1926.[1]

The Watts to which Rodia moved in 1921 was small-town America, and the area around the towers still retains some of this flavor. Narrow streets flank deep, narrow lots that back onto wide alleys. The deep lots allowed enough room for a family to have a small stable and a windmill with a water tank. The wide alleys provided sufficient space for a horse and buggy to turn around. Until recently, a windmill still stood on 108th Street, just south of the towers, and the sounds of chickens and a rooster could still be heard at the end of 107th Street.

When Rodia bought his lot at 1765 East 107th Street, it was called Robin Street, and Pacific Electric Red Cars rattled past the property on the way to and from the Watts Depot and Santa Ana. Main Street, now 103rd Street, boasted numerous commercial establishments. Several churches served the area, including the Watts Baptist and Watts Methodist, the first major churches, followed by the Macedonia Baptist Church and the African Methodist Episcopal Church, established by African Americans. During Prohibition, Watts was also home to one notorious roadhouse, the Watts Tavern.

Watts was surrounded by small truck farms owned by Japanese families. Iva

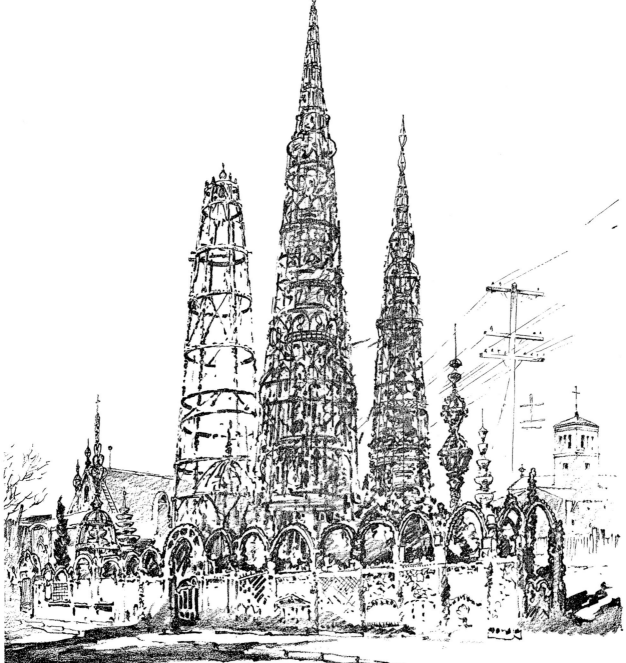

The Watts Towers site looking northwest with the South Wall in foreground. From left to right behind the wall: Rodia's house with ornamented roof (but no ornamented chimney); the A Tower and B Tower; the Gazebo behind the unfinished West Tower; the Center Tower without the large rings but with the outer vertical columns and bands added after the Long Beach earthquake; the East Tower with added columns and bands; and the Ship of Marco Polo (the taller spire should be on the right. The lowest two wall panels have been added since 1929).

Drawing by Charles Owens, ca. 1938. Courtesy Houghton Mifflin.

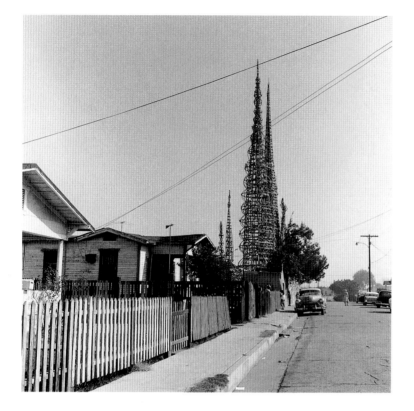

*View looking east
on 107th Street.*

Photograph by
Seymour Rosen, ca. 1963.
Courtesy SPACES.

Tagori, who later became "Tokyo Rose"
during World War II, grew up in a family
that owned several plots of land in the
area, including one where Will Rogers Park
is today. Iva and her brothers returned to
Japan before the war, and one brother was
shot down flying for Japan in the attack
on Pearl Harbor. When his body was recov-
ered, he still wore his Compton High School
graduation ring.[2]

In addition to the Japanese, Watts
was also home to Germans, Mexicans
(many of whom had originally immigrated
to the United States to avoid the military
draft in their home country, just as Rodia
may have done), Jews from Central Europe,
Greeks, and African Americans migrating
from the southern United States. African
Americans originally settled along the
southern edge of Watts, on a tract restricted
to blacks only. But by the time Rodia moved
onto Robin Street, at least one African
American family lived north of his property,
across Santa Ana Boulevard.

In 1988, Joyce E. Jeffers, who grew up
on Santa Ana during the 1920s and '30s,
remembered walking at night with her sis-
ter to the movie theater on Main Street.
She recalled that in those days none of the
families in Watts ever locked their doors.
One of her fondest memories was of a
Mexican family who made fresh tamales to
sell to their neighbors. The tamales were
always kept warm on the back of the stove,
and if the Mexican family happened to
be out, they left the back door open for
their clients. If people wanted to buy tama-
les, they just walked in, helped themselves,
and left the money on the kitchen table.
Mrs. Jeffers revealed that no one in Watts
thought of Rodia's behavior as strange,
eccentric, or unusual. In her words, Simon
Rodia was simply "the Italian guy, and that's
what the Italians did."[3]

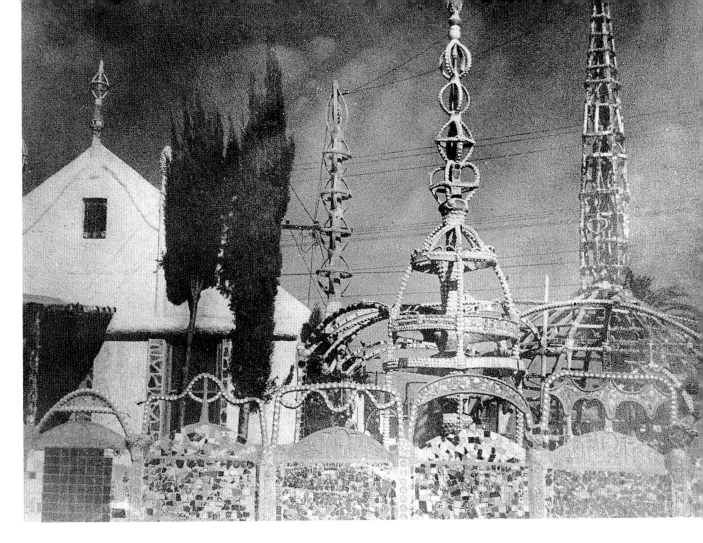

When Rodia left 107th Street in 1955, the Watts he left was not the Watts to which he had come in 1921. World War II had brought great changes to the entire Los Angeles area, including his neighborhood. An unprecedented economic boom fueled by postwar industrial growth, particularly in the burgeoning aircraft industry, and a tremendous demand for housing by returning GIs and their families, devoured most of the remaining vacant land in Los Angeles. No longer was Watts surrounded by truck farms. Unplanned or, at best, hastily planned urban sprawl now enveloped the area. Major industrial plants loomed over residential blocks. The population of Watts also changed, as economically successful families of all ethnic groups moved out and more African American

The Watts Towers site, looking north from 107th Street. The wall panels have ornamented, open framework on top. Rodia's house is on the left behind the South Wall. Left to right are the chimney spire, east of the house facade, the A Tower, and the Gazebo.

Photographer unknown, ca. 1946. Courtesy Ekona Company.

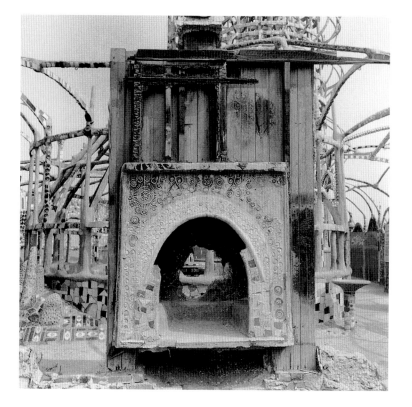

*View looking east
from inside the
burned house, show-
ing the fireplace
with the Gazebo in
the background.*

Photograph by
Seymour Rosen, ca. 1959.
Courtesy SPACES.

families from the South moved in, all of
them seeking jobs in the growing industries.

One change that may have affected
Rodia more than is immediately apparent
was the radical transformation of trans-
portation modes that Los Angeles experi-
enced in the 1950s. Until then, Watts was
a major transportation hub for the south-
ern end of Los Angeles County. Watts
Depot was still the location for transfers
to Orange County and the South Bay, as
well as a stop for those on their way to or
from Long Beach and San Pedro. All that
changed when Los Angeles began its love
affair with the automobile and switched to
the flexibility of buses to provide public
transportation. Suddenly, there were no
more Red Car lines. The depot was boarded
up and part of it became a tailor's shop.

Before the 1950s, hundreds, if not
thousands, of people passed alongside
Rodia's property every day. His towers were
a prominent feature of the Los Angeles
urban landscape. Now no one passed by
to enjoy Rodia's creation. In addition to his
increasing age (Rodia was seventy-six when
he left Watts), this sudden lack of an audi-
ence and the increasing urbanization of
his neighborhood probably influenced his
decision to leave.

For whatever reasons, one day in 1955,
Rodia handed the deed to his property to
his neighbor, Louis Sauceda, got on a bus,
and headed for Martinez, California, where
his sister's family lived.[4] Sauceda sold the
property for $500 or less to another neigh-
bor, Joseph Montoya, who apparently
thought it had commercial potential for
housing a taco stand. Other than that,
Montoya ignored it, not realizing what he
had so cheaply come to own.

During this time, perhaps looking
for money or valuables that they believed
Rodia might have hidden, vandals broke
into his abandoned property and caused

extensive damage to the seashells, plates, and bottles in the walls. Because neither Sauceda nor Montoya had any idea what the towers were or that they had inestimable value, they did not repair any of this early damage. In fact, from a conservation point of view, it may have been for the best that such early damage was not repaired haphazardly. In the moment, however, the absence of both owners from the site soon permitted even greater vandalism. In late 1956, Sauceda was unable to prevent someone from burning Rodia's house to the ground.[5]

Montoya's lack of interest in the property also inadvertently saved the towers from early destruction. In 1957, the City of Los Angeles Building and Safety Department issued an order to "demolish the fire-damaged dwelling and remove the dangerous towers." The demolition order was never served because, for two years, the city could not find the owner. Whenever inspectors showed up at the gate, the site appeared to be abandoned.

In 1959, two local young men, William Cartwright, a film editor, and Nicholas King, an actor, came to see Rodia's Watts Towers. When they observed the neglect and damage to the sculptures, they immediately sought out Montoya and bought the property from him for $20 cash—all they had on them at the time—plus a promise of several thousands more. Their intention was to save the towers from destruction. A friend of Cartwright's, architect Edward Farrell, went to City Hall to get a permit to build a caretaker's cottage on the site. Instead, he found the demolition order. What happened next is one of the most successful efforts at historic preservation in Los Angeles.

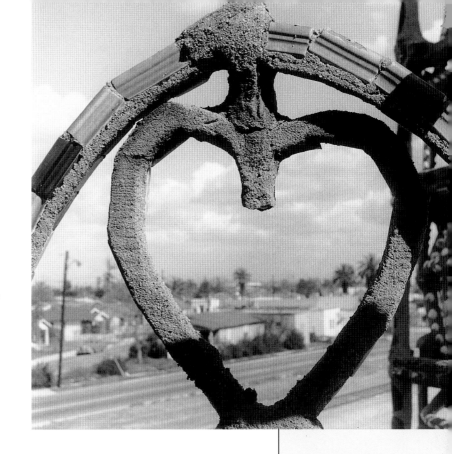

The railroad and Pacific Electric train tracks seen through a detail of a heart on a connector between the East and Center Towers.

Photograph by Seymour Rosen, ca. 1967. Courtesy SPACES.

In 1961, at the end of a presentation on the Watts Towers at the University of California in Berkeley, Rodia answered questions from the audience. He avoided the question of one student who wanted to know the relevance of the heart symbol, so prevalent in the towers. Finally forced to answer, Rodia exclaimed, "You're a young man. You know what the heart means!"

NOTES

1. Mary Ellen Bell Ray. *The City of Watts, 1907 to 1926*. Los Angeles: Rising Publishing, 1985: 1, 63–65.

2. Ibid.

3. Personal interview with Joyce Jeffers, 1990.

4. "Spires Are Monument—Builder of Bizarre Towers Disappears." *Los Angeles Times*, 4 June 1956.

5. Calvin Trillin. "A Reporter at Large: I Know I Want To Do Something." *The New Yorker*, 29 May 1965.

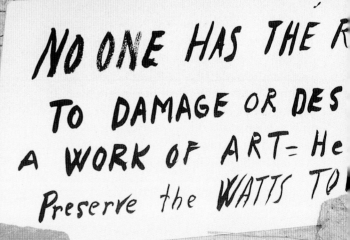

Saving the Towers

If building the towers was the solitary endeavor of one man over a thirty-four-year span (1921–55), preserving them has proven to be anything but a lonely job. It first involved many dedicated individuals, private citizens who chose to embrace the cause of saving the monumental sculptures.

View of the South Wall with a committee fund-raising sign on the day of the load test, 10 October 1959.

Photograph by Seymour Rosen, 1959. Courtesy SPACES.

Their personal destinies came to be inextricably intertwined with the fate of Rodia's masterpiece.

With help from dozens of Los Angeles area residents—among them artists, teachers, and writers—William Cartwright, Nicholas King, and Edward Farrell formed a citizens group, the Committee for Simon Rodia's Towers in Watts, to fight the destruction of the monument. From local residents and art lovers around the world, the group raised thousands of dollars and enlisted professional support in their cause to save the towers.

The committee vowed to stop the demolition at all costs. Their efforts in early 1959 generated more than a hundred newspaper and magazine articles in local and national publications, as well as reports in England, France, Italy, Japan, and other countries. All these stories centered on the "fight to save the Watts Towers" or the "fight against City Hall."

The real issue was safety. Were the towers unsafe?

Rodia had built without written plans, consequently the City of Los Angeles Building and Safety Department could not resort to a "plan check" to see if the towers complied with the building code. The rough-hewn nature of the sculptures, their unique construction, and the decrepit condition of the apparently abandoned site, had all

Opposite:
View of the West Tower and protest sign on the day of the load test.

Photograph by Seymour Rosen, 1959. Courtesy SPACES.

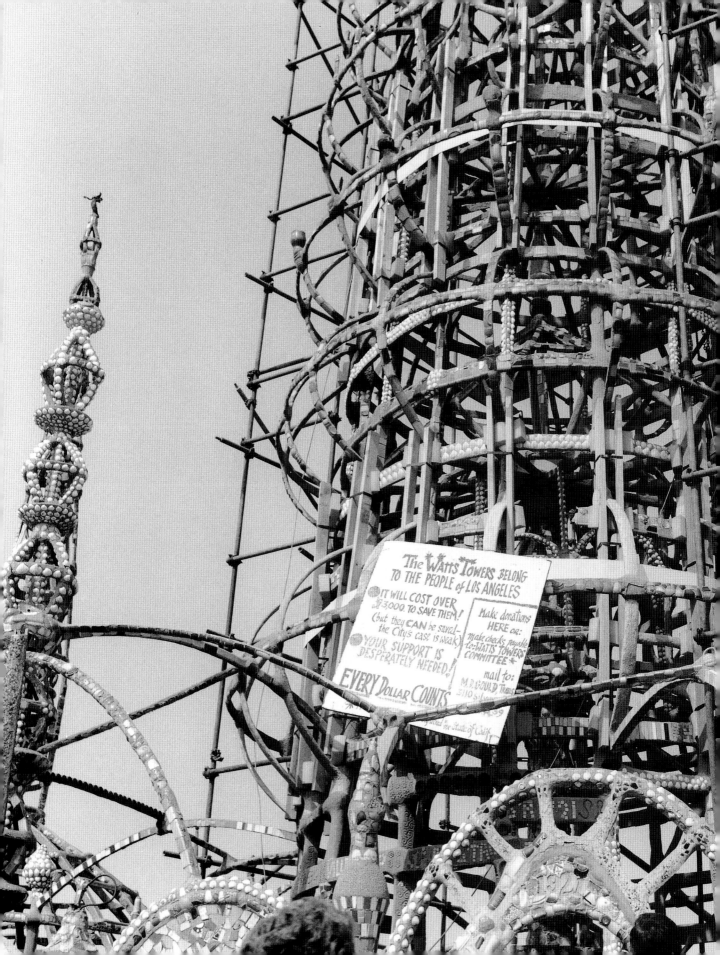

The Watts Towers BELONG
TO THE PEOPLE of LOS ANGELES

● IT WILL COST OVER
$3000. TO SAVE THEM!

(but they CAN be saved—
the City's case is weak)

● YOUR SUPPORT IS
DESPERATELY NEEDED!

EVERY Dollar COUNTS

Make donations
HERE or:

make checks payable
to: WATTS TOWERS
COMMITTEE ●

mail to:
M.P.GOULD, Treas.
3110 S....
....99

....around the State of Calif.

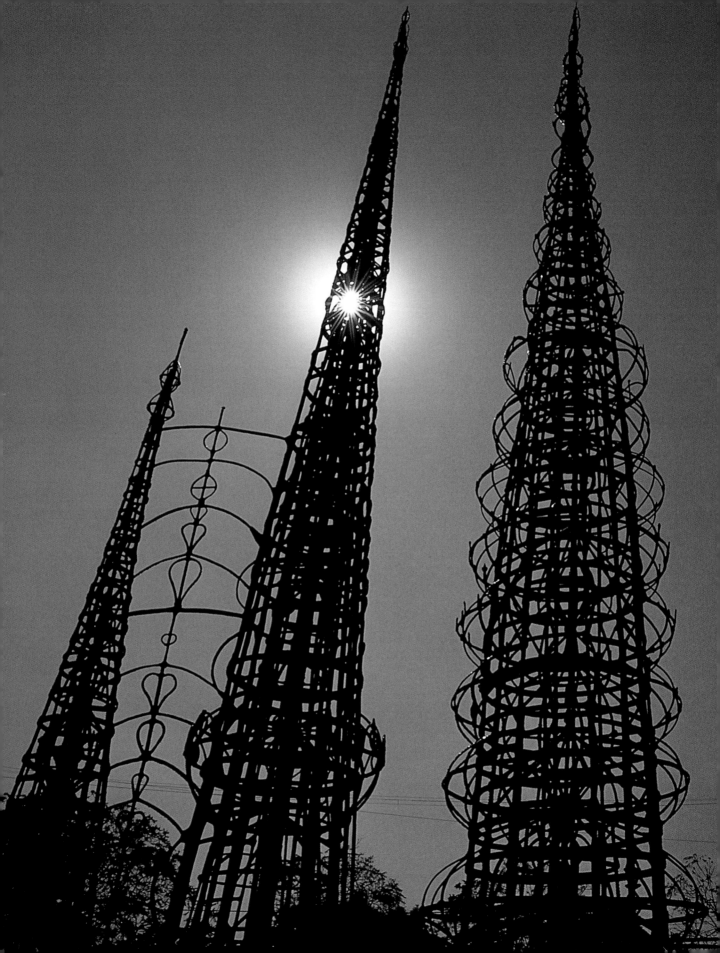

combined to trouble the rigid bureau-
cratic mind.

The Building and Safety Department's
legion of inspectors and engineers com-
piled a comprehensive structural analysis
purporting to show that the towers were
unsafe. High winds or earthquakes were apt
to cause them to topple or collapse, they
argued. One of the towers was said to be
about to fall of its own weight. At a heavily
attended, two-week-long Municipal Court
hearing in 1959, the chief of the Building
and Safety Department and his staff set out
to prove that Rodia's Watts Towers were
a risk and ought to be demolished.

The same inspectors who had inter-
viewed Rodia in 1948 admitted that, prior
to that day, they had never seen the Watts
Towers, nor had they ever received a com-
plaint about the structures. Nonetheless,
the department's civil engineers decried
the fact that the towers had been built
without permit, plans, inspection, or other
government review. Department staff
members testified that they had measured
the three largest towers—which they mis-
takenly reported to be 31.7, 28.65, and 23.16
meters (104, 94, and 76 feet) tall, heights
considered excessive relative to the struc-
tures' supposed strength. City inspectors
and engineers further testified that certain
of the tower legs were cracking and claimed
the towers could no longer sustain the nat-
ural forces imposed on them. Specifically,
they charged that the towers did not comply
with the Los Angeles Building Code.

When Kenneth Ross, general manager
of the Department of Municipal Arts, ques-
tioned the fate of the Leaning Tower of
Pisa if it were located in Los Angeles, they
answered without hesitation that it would
be declared unsafe and recommended
for demolition.

The committee members thought
that, in order to prevail in court, they would

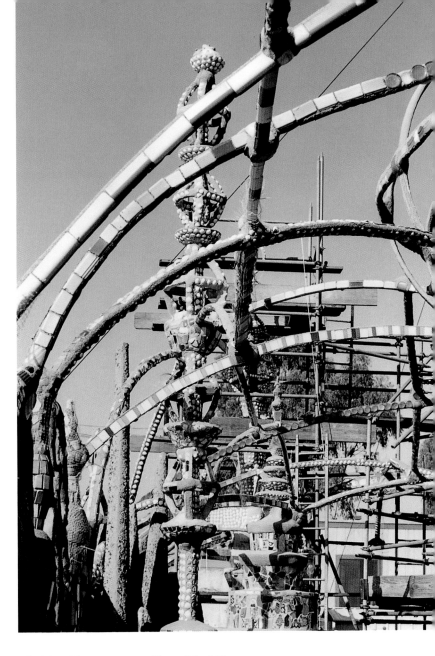

*The Watts Towers,
view from the north.*
Photograph by
Marvin Rand, 1986.

*View of the B Tower,
lower center, with the
South Wall on the left
and overhead connec-
tors between the A, B,
and West Towers.*
Photograph by
Bud Goldstone, 1992.

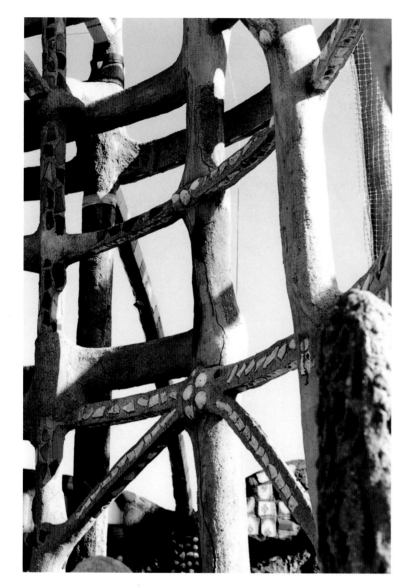

Detail of the lower portion of the Center Tower, looking east.

Photograph by
Bud Goldstone, 1992.

Opposite:
Looking south through an opening in the rear gate to the Gazebo, center, and A Tower, right.

Photograph by
Seymour Rosen, 1959.
Courtesy SPACES.

have to prove that the towers were not a building, and therefore should not be required to comply with the building code. For their part, city engineers failed to realize that the sculptures were in fact more than sufficiently strong to resist high winds and earthquakes and so posed no threat to the community.

The hearing judge, in whose hands rested the fate of the towers, found himself completely at a loss. He was professionally trained as a lawyer, not an engineer, art historian, or conservator. On one hand, from art lovers and connoisseurs worldwide, both directly and in the press, he was assured that the towers were a great work of art and must not be demolished. On the other, he was advised that city engineers, using the building code, found the towers imminently unsafe. Jack Levine, the committee's volunteer attorney, sympathized with the judge. It seemed to both men the most confounding case either had ever tried.

In the courtroom, the committee's engineer (Bud Goldstone, co-author of this book) whispered in Levine's ear, pointing out erroneous facts presented and false conclusions drawn by the city engineers. Fortunately, the chief of the Building and Safety Department was so certain the towers were a risk that he agreed to the challenge of the committee's engineer—if safety was the issue, conduct a load test.

In a calculated attempt to preserve Rodia's masterpiece, the committee itself offered to try to pull down the tallest tower. In accepting the offer, the city made a fundamental error. The committee's engineer was an expert in aeronautical structures. When he first saw the towers, he immediately realized that Rodia had intuitively built a structure more familiar to an aircraft designer than to an architect or civil engineer. An entirely different set of design and

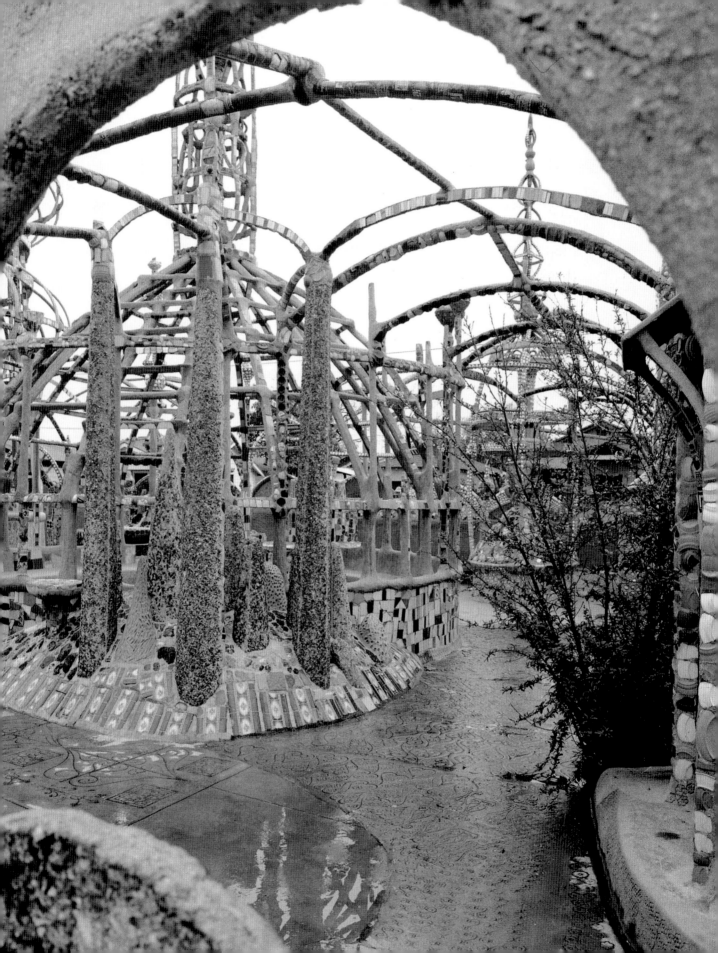

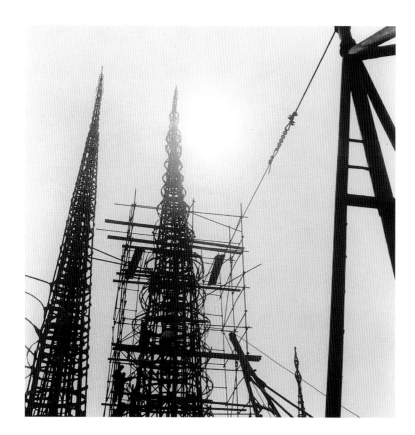

Detail of the load test
rig looking south from
the winch truck with
the Center Tower on
the left, and the West
Tower with scaffold-
ing in the center.

Photograph by
Seymour Rosen, 1959.
Courtesy SPACES.

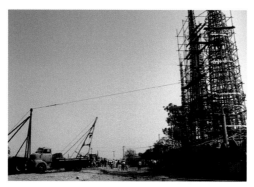

View looking east,
showing the cable
from the winch
truck to the scaffold
platform by the
West Tower.

Photograph by
Jay Weynn, 1959.

structural principles was in force than those in building construction.

Many managers and directors at the company employing the committee's engineer were personally supportive of his involvement with the effort to save Rodia's towers, but the company itself was officially opposed. North American Aviation, Inc. (now Boeing North American) needed Building and Safety Department approval to move its products through Los Angeles streets to delivery sites. The company was not pleased that one of its senior engineers had volunteered for such an off-beat technical experiment, particularly one opposed by the Building and Safety Department. To ease the company's concerns and avoid city complaints, the committee's engineer took a leave of absence from his job.

Meanwhile, his living room rapidly assumed the appearance of an aerospace laboratory. Friends and colleagues manned calculators on almost every piece of furniture as they helped determine the safety issue by calculating the strength of each of the hundreds of members in the tallest structure. Ultimately, more than twenty engineers and technicians, including two professors from the University of Southern California and the University of California at Los Angeles, helped with the calculations and, finally, the test. It was the most demanding professional task the committee's engineer had ever undertaken. If the load test failed, he was sure to be forever known as "the guy who pulled down the towers."

With funds donated by hundreds of supporters, a 21.3-meter (70-foot) scaffold was erected on the north side of the tallest tower. Dozens of the tower's sculptural bands and columns were wrapped with protective padding. Wooden beams 5 by 10 centimeters (2 by 4 inches) were bound to the padding around the columns.

Steel-reinforced straps were wrapped entirely around the tower at several levels, from 4.6 to 21.3 meters (15 to 70 feet) high. Steel beams up to 9.1 meters (30 feet) long joined the ends of the straps. A 10-meter (33-foot) high platform was erected, and a hydraulic cylinder lifted onto the platform. Steel cables connected the cylinder to the tower on the south and to a winch truck, parked 95 meters (150 feet) away across the railroad tracks on the north.

More than a thousand people, tense with fervent hope and apprehension, watched on that Saturday afternoon in October 1959, along with local television crews and reporters from as far away as New York. When everything and everyone was ready, the test began.

Slowly, 453 kilos (1,000 pounds) at a time, the hydraulic cylinder was pressurized to apply a 4.5-metric-ton (10,000-pound) pull on the tower. The winch truck across the railroad tracks reacted the load. With the full load imposed on the tower, Rodia's sculpture stood firm.

Though the tallest of the towers easily sustained the agreed load—equal to the force of a 130-kilometer (80-mile) per hour wind—the main steel beam that attached the cylinder to the tower began to bend. The tower had proven stronger than a steel beam.

The test was stopped. The chief of the City Building and Safety Department had no choice but to proclaim Simon Rodia's Watts Towers safe. As he surrendered the red "unsafe" sign to the committee, the crowd cheered.

During the following week, headlines, news reports, and feature stories about the load test were published in the *New York Times, Los Angeles Times, Los Angeles Herald Examiner, Los Angeles Herald Express, Los Angeles Mirror-News, San Francisco Chronicle, Hollywood Citizen News, South*

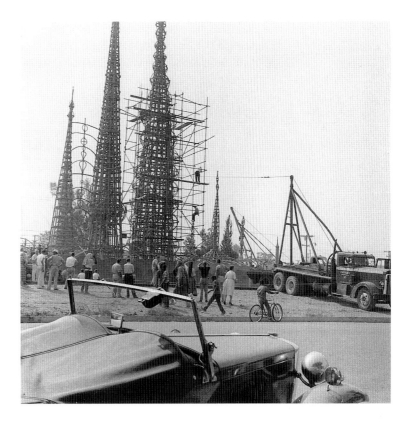

The load test seen from the north.

Photographer unknown, 10 October 1959. Courtesy the Committee for Simon Rodia's Towers in Watts.

Committee members in the Gazebo celebrating the successful load test. From left: Edward Farrell, AIA; Bud Goldstone, senior test engineer; Nicholas King, actor; Herbert Kahn, AIA; Jack Levine, attorney-at-law; William Cartwright, filmmaker.

Photograph by Seymour Rosen, 1959. Courtesy SPACES.

End Bee, and UCLA *Librarian.* They pro-
claimed the news that "Sam Rodia Built
Well" and "Watts Towers Withstand
Torture Test."

Despite such widespread publicity,
myths about the 1959 load test have per-
sisted for almost four decades. In 1976, *Los
Angeles Times* columnist Jack Smith wrote
in his book *The Big Orange,* "They tried to
pull them down, you know."[1] In 1996, Gwyn
Headly claimed in *Architectural Follies in
America,* "They [the Los Angeles Building
and Safety Department] took jackhammers
to the structures, failed to make an impres-
sion, and retired defeated."[2]

Immediately after the towers passed
their test, committee volunteers set to
work. Some began to offer free art classes
on the site for neighborhood children.
Others added a floor to Rodia's burnt-out
house, raised a canopy where the roof had
been, put up tables, and set out art sup-
plies. And the children of Watts came.
The committee also tried to make repairs
to the towers and opened them to the pub-
lic for a small fee.

Astonishing news then reached the
committee: Rodia was not dead, as all
had presumed; he was alive, living near
San Francisco. In October 1961, four mem-
bers of the committee arranged to stage
a lecture, slide show, and film screening
in Berkeley and San Francisco. They also
planned to visit Rodia in Martinez and
honor him on the University of California's
Berkeley campus.

Elated committee members persuaded
Rodia to abandon his long self-imposed
exile and attend both events. At the end of
the Berkeley and San Francisco presenta-
tions, Rodia was introduced to the audience.
Receiving a standing ovation, he rose from
his front-row seat, doffed the hat that he
had worn throughout the ceremonies, and
bowed elegantly.

For the first time, Rodia spoke pub-
licly about his towers. He even answered
questions on stage after the events and
demonstrated some of his building tech-
niques. When constructing the walls, for
example, Rodia showed how he would work
on them flat on the ground and then pulley-
hoist or tilt them into the vertical position.

Rodia also met San Francisco sculp-
tor and fellow Italian, Benny Bufano, who
befriended Rodia and became his outspo-
ken advocate.[3] During their conversation
Rodia commented, "Cement used to be
twenty-four cents a sack, for a cloth sack.
Now it's a dollar eighty-four and a paper
sack. How you gonna build anything?"

In 1962, an exhibition of Seymour
Rosen's photographs of the towers was
mounted at the Los Angeles County Museum
of Art. The show moved to the San Francisco
Museum of Art, the La Jolla (California)
Museum of Contemporary Art, and to the
University of British Columbia Museum.

In the 1960s, two young brothers
employed by the committee sat outside the
towers collecting donations. As a result
of this and other fund-raising efforts, the
committee was able to buy several houses
on 107th Street in 1962. Members began a
Teen Post and started plans to build a per-
manent art center on the block. The Watts
Towers Art Center—designed by architects
Edward Farrell, Harold Williams, and
Herbert Kahn—was built in 1970.

Nonetheless, the future of the towers
remained clouded. In 1963, the Century
Freeway plans were published, along with
the announcement of a public hearing to
be held a few days later. The towers were
not shown on any of the drawings, nor in
a three-dimensional model of the area; yet
the freeway had been planned to pass just
one block south of the towers. Though
Rodia himself might have welcomed such
high visibility, the vibrations from constant

Opposite:
Collage of press
clippings about the
load test from March
to November 1959.
Photograph by
Bud Goldstone, ca. 1960.

to Weird Scrap-Inspired Towers

Watts Towers to Be Tested

N.Y. Art Critic Asks Saving of Watts Towers

Totter-Test for To

MIRROR N

'Torture Test' Put On Watts Towers
Monster Cranes Apply 10,000-Pound Stress

Group Plans Watts Towers Stress Testing

Today's the Big Day for Watts Towers

UNSAFE DO NOT ENTER

DECLARED DANGEROUS
BY DEPARTMENT OF BUILDING AND SAFETY

Watts Towers Test Ready

DAILY

Sam Rodia Built Well, His Towers Defy Torture Test

Tests OK Watts Towers

Watts Towers OKd in Tests

2,500 Watch as Sculptures Sustain Pain Only Pressure Pull of 10,000 Pound

Cranes Fail Structure

Call Both Sides to Hearing On Steel

Leads Calif.

HERALD and EXPRESS

*Erika Kahn at the
art center in Watts,
ca. 1963.*

Photograph by
Herbert Kahn.

traffic could have shaken loose ornaments and threatened the integrity of his work.

Committee members spoke out at a community hearing attended by property owners in the freeway's path. Yet again, they explained the priceless value of the Watts Towers and showed the freeway planners where the towers were located. The freeway, which finally opened in October 1993, was moved more than five blocks south, though probably for reasons other than its proximity to the towers.

The same year that civil unrest resulted in the so-called Watts Riots, the city took a step to vindicate its initial hostility to the towers. In March of 1965, they were officially designated as Los Angeles Cultural Heritage Monument Number 15.

The towers stand only five blocks from 103rd Street, which was reduced to ashes and rubble by the violence. During the riots, several committee members and art teachers were unable to get home safely; so neighbors on 107th Street took them into their homes. Neighbors also made sure that no harm came to the towers. Rodia's art did not in any way represent the institutions that the people of Watts blamed for their oppression.

Yet the preservation of Rodia's fragile glass, shell, and pottery ornaments, as well as the mortar and steel reinforcements of his structures, demanded a major conservation effort. After the 1959 load test, the committee employed artist Tom Wills and a local contractor, Williams Waterproofing, to fill cracks and waterproof the surfaces.

Earthquakes, winds, and ground settlement had created cracks in the thin mortar shell around sculptural members. Aging mortar lost its bond to the steel reinforcement. Rain and fog penetrated to the steel through cracks in the mortar cover, which resulted in rusting of the metal. As long as the mortar retained its

bond to the steel, and cracks were filled as soon as they occurred, the sculptures remained strong. But by 1975, faced with more than $50,000 in needed repairs to the towers, the committee had run out of money.

Fortunately, the general manager of the City Municipal Arts Department, Kenneth Ross, helped to rescue the towers. He assisted the committee in deeding to the city the towers, art center, and adjacent property acquired by the committee, effectively placing the site under operational control of the city. Committing itself to perform the needed repairs, the city accepted the gift.

The towers were initially defined by the city as a "public building," its restoration assigned by city procedures to the Public Works Department. But bureaucratic problems delayed the crucial repairs.

In late 1977 and early 1978, rain, wind, and flooding of a magnitude occurring only once every hundred years caused large portions of the structure to crack. Cement bands several feet long and hundreds of loosened ornaments fell and shattered on the patio floor. Once more, newspapers and magazines across the nation covered the story to save the towers.

Rodney Punt, assistant general manager of the City Municipal Arts Department, outlined steps essential to the conservation of the towers. With the committee, Punt invited a city architect, conservation consultants, conservators from the J. Paul Getty Museum, Norton Simon Museum, and the Los Angeles County Museum of Art to develop a plan for long-range conservation of the Watts Towers and advise the City Public Works Department on specific techniques.

At first welcomed, this expert advice eventually went unheeded by those heading the restoration program. In 1978, the City

A finial from the Gazebo after removal for repair. The removal revealed a portion of the broken green bottle bases over a kitchen colander used as a form by Rodia.
Photograph by Bud Goldstone, 1992.

A finial from the Gazebo after removal for repair. The removal revealed broken green bottle bases and pieces of pottery.
Photograph by Bud Goldstone, 1992.

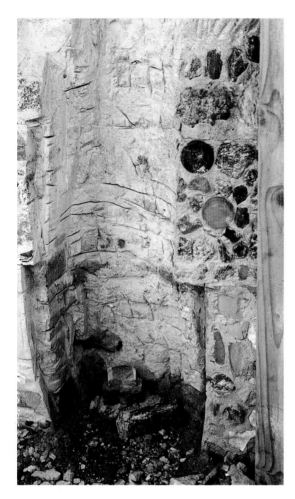

*A vertical opening
cut into the base of
the Center Tower to
repair damage, ca.
1996. The column had
been removed prior to
repair. The thin shell
of concrete and mesh
may be seen on the
left of the cutaway
area. Red brick and
concrete within the
shell are also exposed.*

Photograph by
Bud Goldstone.

Department of Public Works approved a
$209,000 contract for repair of the towers;
but the architect awarded the contract chose
to disregard the recommendations of the
1977 conservation plan.

Although both the plan and his city
contract specified the erection and use of a
work scaffold, the architect instead directed
his crew to climb the West and Center
Towers and the Gazebo, treading on previ-
ously undamaged sculptural bands while
applying buckets of highway-repair mortar
to cracks. The crew scraped loose orna-
ments from the sculpture with putty knives
and tore off whatever cracked and damaged
bands they could reach. Then they dropped
them to the ground below, thus destroying
the ornaments and bands as they struck the
patio floor.

Committee members had already
objected to the plans of the chosen archi-
tect, particularly his notion to "make the
towers look as good as new." Now they
watched the crew's negligence with increas-
ing dismay. A public controversy soon arose.
The committee again proved its diligence
by filing a lawsuit that temporarily brought
restoration work to a halt while the issues
could be examined in court.

On behalf of the committee, the
Center for Law in the Public Interest suc-
cessfully sued the city to stop the work and
provide reparations. The committee also
won a petition to the California Supreme
Court to cancel the architect's city contract
and recapture the $209,000. On the basis
of this successful petition, ownership of
the towers, as well as responsibility for their
repair, were turned over to the State of
California, so that the towers might qualify
for state park conservation funds. In turn,
the state proclaimed the Watts Towers of
Simon Rodia a California Historic Park.
Thus began a long, at times circuitous, but
ultimately successful restoration program.

In September 1978, concerned for the integrity of the towers it now owned, the State of California formally terminated the city's initial work and the following year began its own restoration program, the stabilization of the three tall towers. Instrumental in this effort were the State Parks and Recreation Department, the State Office of Historic Preservation, and the Office of the State Architect. The first formal conservation guidelines were commissioned by the state and developed by the Ehrenkrantz Group.

On top of the retrieved $209,000 from the canceled city contract, in 1980, State Senators Alan Sieroty and Bill Greene led the legislative effort to allocate a further $1,000,000 in state financing from an omnibus parks bill. Over the next five years, the three tallest towers received their first comprehensive stabilization since Rodia's departure thirty years earlier. Scientists from the Getty Conservation Institute and the Los Angeles County Museum of Art, and private conservators provided expert advice to the state crew (and later to the city) for all remaining work on the sculptures.

In 1985, the State of California approached the City of Los Angeles to assume once more its pledge of maintenance. The state had by then exhausted its allocated funds in completing repairs on the three tallest towers. Still much remained to be done, including deferred maintenance of the walls and twelve other sculptures. Skeptical of the city's ability to accomplish the needed work successfully, the committee, through the Center for Law in the Public Interest, resumed its lawsuit. Thanks to a concerted effort by editors of the *Los Angeles Herald Examiner* and its architecture critic, Leon Whiteson, the towers again became news.

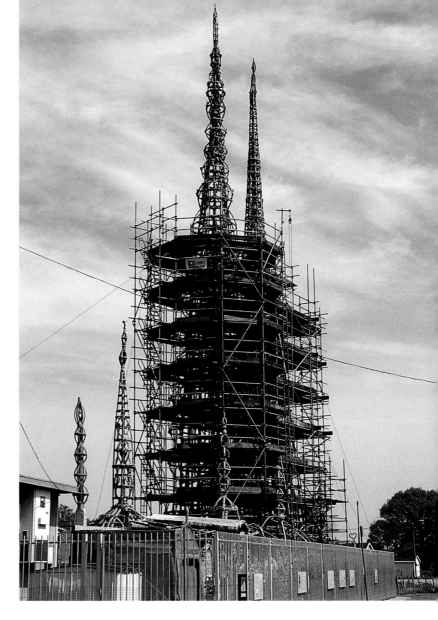

The towers, shrouded in scaffolding, undergoing conservation. Work on the upper levels was completed and the scaffolding removed in December 1996.

Photograph by
Stephen Gill, 1997.

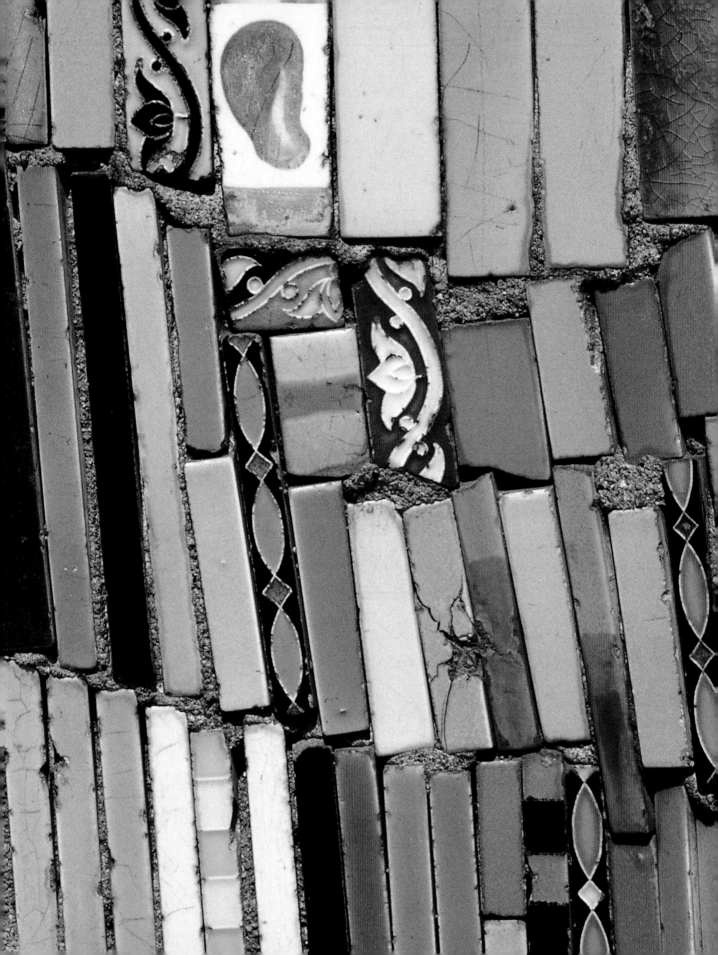

In State Superior Court, the committee, the city, and the state agreed to settle their ongoing 1979 law suit. In the settlement, the city consented to assign the restoration program to its Cultural Affairs Department (successor to Municipal Arts) and was ordered to provide $800,000 for conservation over an initial five-year period. The funds were to be used to complete repairs on the remaining sculptures and pay for maintenance once the repairs were completed.

His duties by then having been expanded to include those of city historic preservation officer, Rodney Punt officially redefined the Watts Towers of Simon Rodia as a "sculpture" and the task at hand as conservation of an artwork, not a building. In early 1986, Punt and the committee assembled a team that has proven its competence and dedication for over a decade. The effort was strengthened by support from the Getty Conservation Institute, the Los Angeles County Museum of Art, and a dedicated staff of city employees and consultants who have made the restoration of the Watts Towers one of the premier art conservation programs in the world.

The initial restoration guidelines were upgraded with reference to evolving techniques and materials; the program's progress was tracked by sophisticated computer technology. Every square inch of the towers has now been systematically photographed to provide a critical baseline record for continuing restoration. All concerned have been determined to ensure that, at a minimum, the restoration program meets standards set by the U.S. Secretary of the Interior. In part as a result, in 1990, the Watts Towers were awarded the status of National Landmark, only the third such site so honored in the City of Los Angeles.

This exemplary city-led conservation program was severely challenged by the 1994 Northridge earthquake, which damaged the three tallest towers, the walls, and some smaller sculptures. The seven other sculptures previously restored were not affected by the quake. Beginning in July 1994, funding of nearly $1,000,000 from the U.S. Federal Emergency Management Agency has advanced the restoration of Rodia's sculptures.

NOTES

1. Jack Smith. *The Big Orange.* Pasadena, California: Ward Richie Press, 1976: 121–26.

2. Gwyn Headly. *Architectural Follies in America.* New York: Preservation Press/John Wiley & Sons, Inc., 1996.

3. Committee minutes, 1965.

Detail of a South Wall panel.

Photograph by Stephen Gill, 1997.

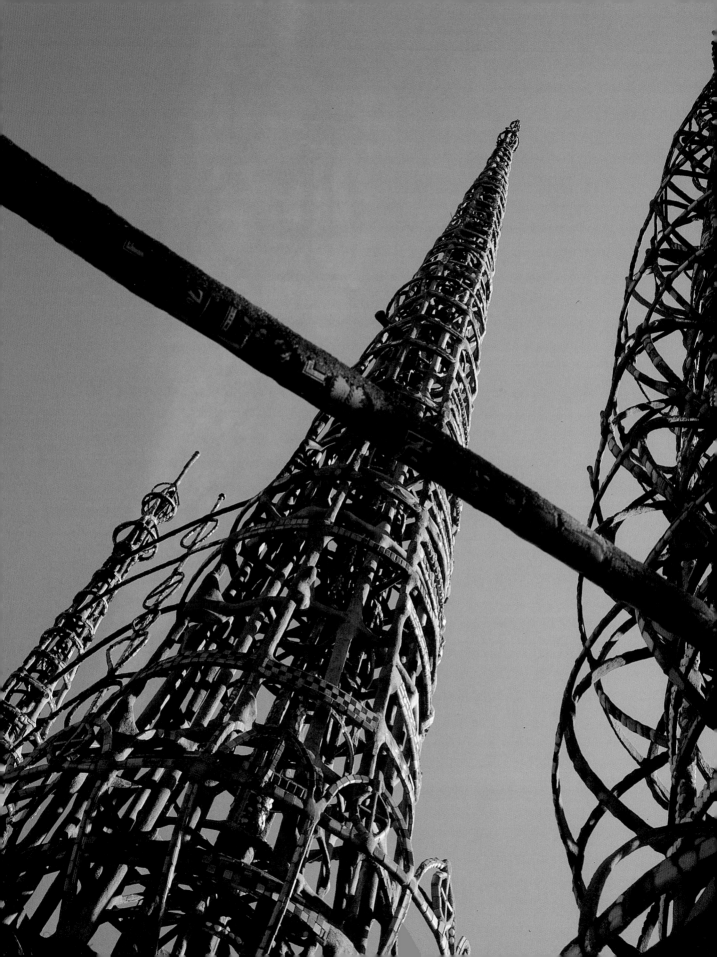

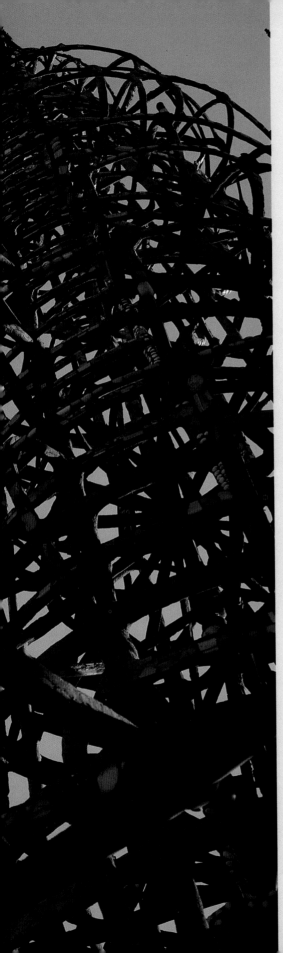

Acres of concrete figures clothed in bangles of broken glass in Chandigarh, India; Picassiette House and Garden, completely covered by mosaic, in Chartres, France; a half-organic, half-sculptural concrete construction in Hauterives, France; a narrow lot covered by structures built from empty bottles and cement mortar in Simi Valley,

View from the patio of, from left, the East Tower, Center Tower, and West Tower.

Photograph by Marvin Rand, 1987.

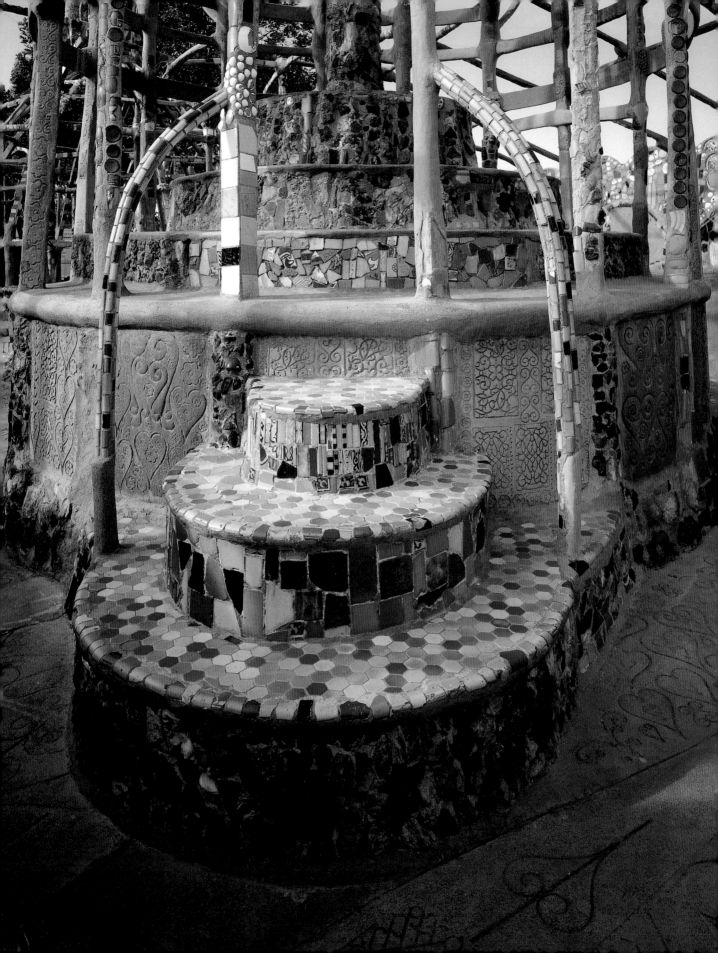

California; Simon Rodia's towering sculptures in Watts: these are only a few of the phenomenal structures that idiosyncratic artists have created throughout the world.

What inspired the imaginations of these creators and drove them to spend much of their lives on such projects? Somewhere in the human psyche, buried deep, exists the urge to create. Intuitive, unpredictable, it sometimes bursts forth in miraculous ways. The instinct is mysterious, elusive. When manifested by someone not formally trained in art, this creative urge is all the more enigmatic.

If someone who has invested years in training and spent large sums of money for the privilege of making art, in fact creates something wonderful, we expect

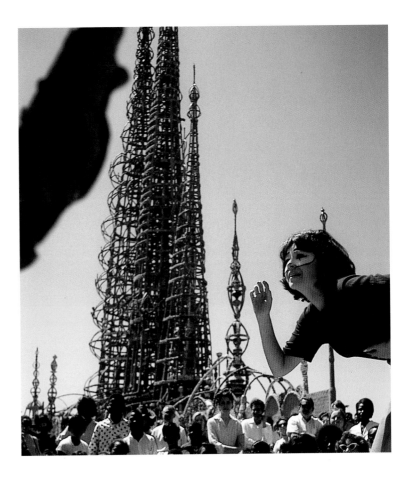

Opposite:
View looking north at the south steps of the West Tower.
Photograph by Marvin Rand, 1986.

University of Southern California street theater event, just east of the Watts Towers.
Photograph by Seymour Rosen, 1966. Courtesy SPACES.

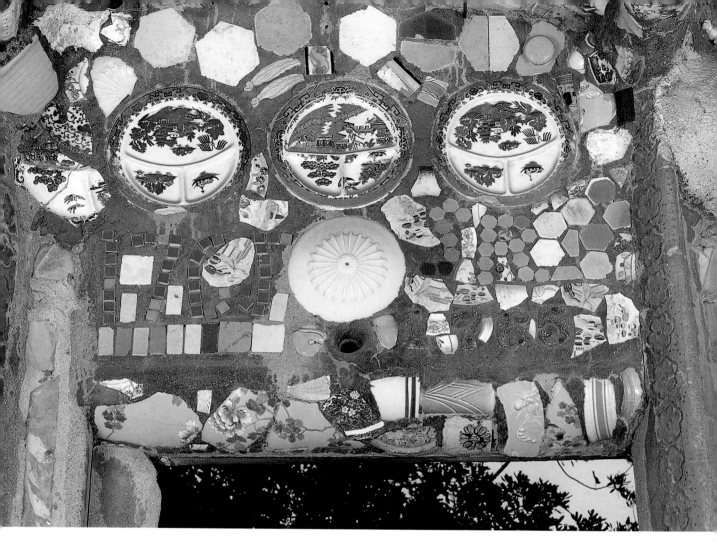

*The canopy over
the entranceway.*

Photograph by
Marvin Rand, 1987.

that creation to inspire, engage, confuse, even repulse us. But when someone like Simon Rodia, an uneducated, impoverished "unknown," spontaneously engages in an artistic endeavor, the work challenges our idea of what art is.

In the preface to his book, *Raw Creation, Outsider Art and Beyond,* the critic John Maizels indicates how far we have come in expanding the definition of art as we approach the end of the twentieth century. Maizels has adopted a more inclusive perspective, one that finds the viewer essential to the process of definition. To consider art as either "academic" or "nonacademic," he argues, is to make a place for works like that of Rodia. Academic art can be seen as adhering to accepted standards by which it may be judged fairly. Did the artists accomplish what they set out to do?

Was the work accomplished in a manner consistent with their goals?

By contrast, nonacademic art is regarded as instinctive creation and cannot be judged by preexisting standards. We seldom know the goals of nonacademic artists, so we cannot know if their goals were accomplished. Perhaps they had no goals at all. Perhaps their art was totally unpremeditated. Nonacademic art must be approached on a much more personal level than academic. Nonacademic art is self-determining. It allows viewers to form their own individual responses.

Even though we are now beginning to accept the works of nonacademic artists and include them in an expanded definition of art, these works still remain in a more tenuous and precarious position than that afforded works of academic art. Typically protected in some way, academic art is housed in a gallery or museum, regarded as a national treasure, or cared for by a private foundation. Or it may remain in a private home for only a few to enjoy; but even so, it is at least relatively safe.

Academic works are rarely subjected to unethical conservation methods or the whims of governmental agencies. No one would dare suggest trashing the Mona Lisa or tearing down the Louvre and replacing it with a parking lot. Yet nonacademic works, such as the Watts Towers, cannot rely on a fixed set of standards, leading to at least some agreement that they are art and thus deserving of protection.

The history of the towers has shown that highly public, nonacademic art can be preserved only if it is owned by a group dedicated to its preservation and one with sufficient financial resources to preserve it, or if the government with jurisdiction over the work proves worthy of the public trust. Fortunately, in the case of the towers, both of these safeguards are now in place.

A top panel in the South Wall, showing lusterware above and engravings below.
Photograph by Bud Goldstone, 1989.

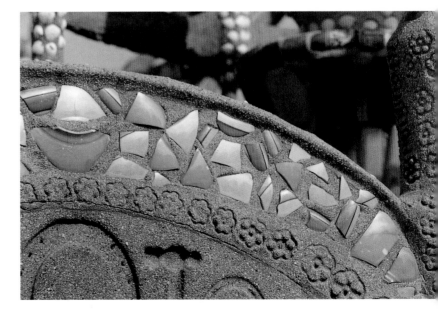

*The "magic wall"
of tiles, pottery,
glass, and cement
created by students
at the entrance to
the Watts Towers Art
Center workshop.*

*Photograph by
Gene Ogami, 1995.*

*The Watts Towers
looking northwest
from the patio floor.
The spires from
left to right are the
West, Center, and
East Towers.*

*Photograph by
Justine Hill, 1977.*

We are all extraordinarily lucky that
the towers still exist today. Rodia's work
has managed to evade building codes that
did not allow for it, survive misguided
"conservation" attempts that sought to
replace elements of the artist's work, and
avoid becoming a private residence or
commercial development.

The towers have meanwhile blazed
new trails to the appreciation and accep-
tance for other visionary environments.
On 13 April 1977, when the Watts Towers
were first listed on the National Register
of Historic Places, they were the only such
work on the list. Now there are nine.

The towers will surely form part of
the urban landscape of Los Angeles for a
long time to come. What happens around
Rodia's work, however, may yet prove sub-
ject to the changing needs and wants of
the community. A few years ago, a develop-
ment plan for the surrounding area was
sponsored by the city. Local opinions were
solicited as an ingredient for a "cultural
crescent" plan. In a series of community
meetings, the people of Watts expressed
their own ideas and needs.

They requested that the four-square-
block redevelopment zone provide not only
a cultural area, but also address a number
of social problems. The plan called for a
museum, space for conservation work on
the sculptures, a new art center, a perform-
ing arts center, a music center and theater,
artist-in-residence housing, a child-care
center, a job-training facility, and a restau-
rant, as well as parking for visitors to the
towers and adjacent complex. An earlier
redevelopment plan, proposed by a local
university, showed the entire four blocks
leveled, except for the towers, surrounded
by a reflecting pond in the middle of a
large park.

As nonacademic art, the Watts Towers
have often been subjected to a baffling and

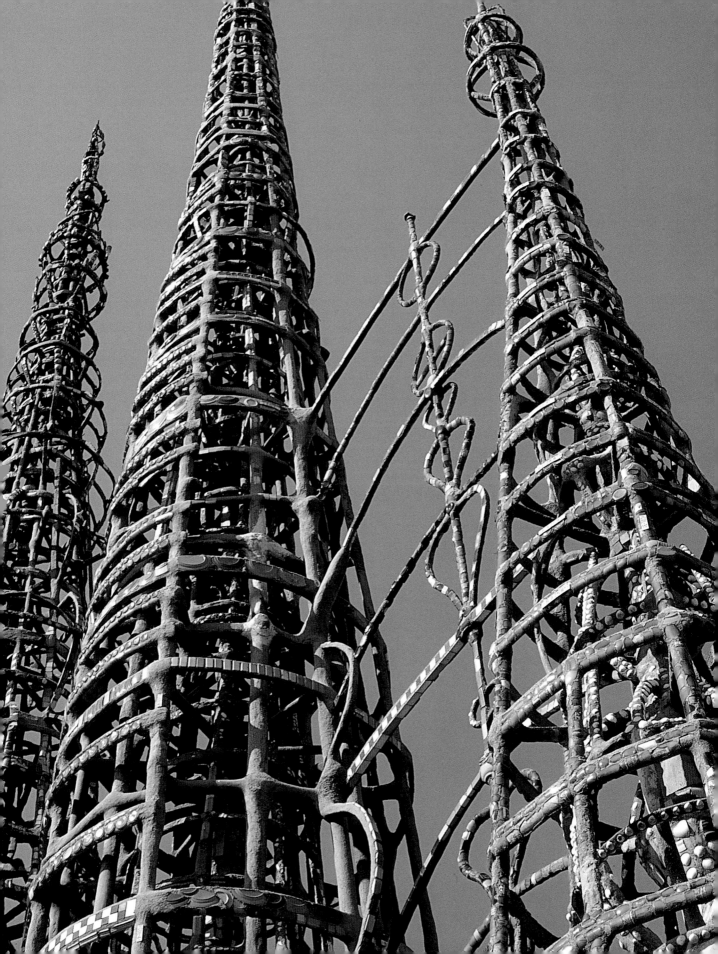

Rodia talking with students and faculty in the auditorium at the University of California, Berkeley, October 1961.

Photographs by
Seymour Rosen, 1961.
Courtesy SPACES.

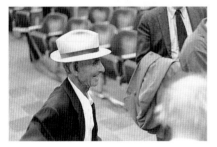

perilous catch-22. To regard them as spontaneous is wonderful. To see them appreciated is exciting. To consider them nonacademic art is idealistic, democratic, and egalitarian. But precisely because Rodia's creation is nonacademic art, each viewer also makes a personal decision as to the future of the towers. And there the danger lies.

It has now been more than seventy-five years since Rodia began his creation on 107th Street. His work exists today only because of his own urge to create and ability to construct well, the dedication of a varied group of people, and the willingness of the City of Los Angeles, the State of California, and the Federal Government of the United States to ensure that the towers will exist for generations yet to come.

But what if only a single aspect of Rodia's life had been different? Would he still have built the towers? What if he had chosen to stay in Pennsylvania, with its harsh climate? What if the right people had not come together, at precisely the right time (and just in time), would the towers have been saved? Not just once, but several times. Ask yourself these questions when you behold Sabato Rodia's towering legacy.

The late Bennie Bufano, also an immigrant Italian sculptor, once remarked of his countryman, Rodia, "Think of that little guy, all by himself. Not a penny from it, not a penny. We don't have those people anymore. After I saw the towers, I wrote a prayer about them. It's a miracle. A thing like that . . . it happens once in a million years."

Suggested Reading

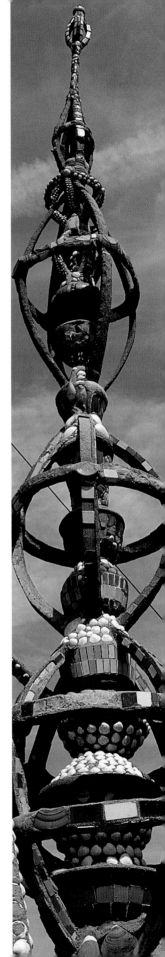

Books and Catalogues

Banham, Reyner. *Los Angeles: The Architecture of Four Ecologies.* New York: Harper and Row, 1971.

Boswell, Peter, and Philip Brookman. *Forty Years of California Assemblage.* Los Angeles: Wight Art Gallery, 1989.

Bronowski, J. *The Ascent of Man.* Boston: Little, Brown & Co., 1974.

Cardinal, Roger. *Outsider Art.* New York: Praeger, 1972.

Maizels, John. *Raw Creation: Outsider Art and Beyond,* London: Phaidon Press Limited, 1996.

Parallel Visions: Modern Artists and Outsider Art. Los Angeles County Museum of Art and Princeton University Press, October 1992.

Ray, Mary Ellen Bell. *The City of Watts, 1907 to 1926.* Los Angeles: Rising Publishing, 1985.

Rosen, Seymour. *In Celebration of Ourselves.* San Francisco: California Living Book, 1979.

Rosen, Seymour, and Paul M. Laporte. *Simon Rodia's Towers in Watts.* Los Angeles: Los Angeles County Museum of Art, ca. 1962.

Seitz, William C. *The Art of Assemblage.* New York: The Museum of Modern Art, 1961.

Zelver, Patricia, and Frane Lessac, drawings. *The Wonderful Towers of Watts.* New York: Tambourine Books, 1994.

Articles

Barr, Alfred Jr. "Homage to Sam." *Art Forum,* 20 July 1965.

"Flashing Spires Built as Hobby." *Los Angeles Times,* 13 October 1937.

"Immigrant Builds Towers to Show His Love for U.S." *Los Angeles Times,* 8 June 1952.

"Spires Are Monument—Builder of Bizarre Towers Disappears." *Los Angeles Times,* 4 June 1956.

Steinitz, Kate T. "A Visit With Sam Rodia." *Art Forum,* 1 May 1963.

Trillin, Calvin. "A Reporter at Large: I Know I Want to Do Something." *The New Yorker,* 29 May 1965.

Ward, Daniel Franklin, and I. Sheldon Posen. "Watts Towers and the Giglio Tradition." *Folklife Annual.* Library of Congress, 1985.

Whiteson, Leon. "Sam Rodia: Our Town's Artist." *Los Angeles Herald Examiner,* 21 April 1985.

_____. "Rodia's Work Rises Above Mere Folk Art." *Los Angeles Herald Examiner,* 22 April 1985.

_____. "Pointing the Way to a Better Watts." *Los Angeles Herald Examiner,* 23 April 1985.

_____. "How Rodia's Monument Can Help Pull L.A. Closer." *Los Angeles Herald Examiner,* 24 April 1985.

Looking north at the spire of the Ship of Marco Polo.

Photograph by Stephen Gill, 1997.

Champions of the Towers

The effort to preserve the Watts Towers of Simon Rodia has demanded so much from so many that no attempt to acknowledge the generosity of all could prove comprehensive. Nonetheless, recognition must be paid to the following. Some names show the title held or role played in the past.

The Committee for Simon Rodia's Towers in Watts

Mae Babitz
Sol Babitz
Melinda Brun
William Brun
Norris Dabbs
James Elliott
Jody Farrell
Bill Firschein
Claire Frith
Esther Gould
Max Gould
Beata Inaya
Willie Kinneman
Lucille Krasne
Paul LaPorte
Jack Levine
Jerry Lewis
Christy Johnson McAvoy
Steve McAvoy
Barrett Miller
Jeanne Morgan
Allen Porter
Seymour Rosen
Nancy Sandquist
Brenda Seville
Kate Steinitz
Bill Watts
Sue Welsh

From the State of California

California Department of Parks and Recreation

Russell Cahill, director
Earl Carlson, supervising architect,
 Division of Development
Steade Craigo, preservation architect,
 Office of Historic Preservation
Knox Mellon, director,
 Office of Historic Preservation
Anthony "Allen" Ulm, Los Angeles manager
 of Community Involvement

Bill Greene, senator
Alan Sieroty, senator
Gerald E. Stanley, restoration supervisor,
 Office of the State Architect

From the City of Los Angeles
Cultural Affairs Department
Virginia Kazor, historic site curator
Jay Oren, A.I.A., staff architect
Rodney Lee Punt, assistant general
 manager and historic preservation officer
Kenneth Ross, general manager
Forest Scott, A.I.A.

Watts Towers Art Center
Mark Greenfield
John Outterbridge
Judson Powell
Noah Purifoy
Curtis Tann

Conservators
Neville Agnew, The Getty Conservation
 Institute
Zuleyma Aguirre, The Watts Towers
Sdravko Barov, The J. Paul Getty Museum
Steven Colton, The Los Angeles County
 Museum of Art
William Ginell, The Getty Conservation
 Institute
Rosa Lowinger, The Sculpture
 Conservation Studio
Pieter Meyers, The Los Angeles County
 Museum of Art
Myrna Saxe
John Twilley, The Los Angeles County
 Museum of Art

Others
James Barnes, North American Aviation
Debby Brewer
Richard Brown
Brad Byer
Center for Law in the Public Interest

Herschell Chipp, UC Berkeley
Sir Kenneth Clark
Sister Corita, Immaculate Heart College
Charles and Ray Eames
The Ehrenkrantz Group
Juan Espinosa
Richard Frazier
R. Buckminster Fuller
William Hale
Henry Hopkins
Walter Hopps
Edward James
Bernard Judge
Sam Hall Kaplan, *Los Angeles Times*
Christopher Knight, *Los Angeles Times*
Edward Landler
Dev Leahy, North American Aviation
Sister Magdalene Mary
Harry Moshenrose, North American
 Aviation
Gerald Nordland
William Osmun, The Los Angeles County
 Museum of Art
Marvin Rand, Marvin Rand & Associates
William C. Seitz
Henry Seldes, *Los Angeles Times*
Jack Smith
Calvin Trillin
Robert Walker, North American Aviation
Leon Whiteson, *Los Angeles Herald Examiner*
Tom Wills
William Wilson, *Los Angeles Times*
Jake Zeitlin
Patty Zeitlin

Acknowledgments

As in all the publications of the Getty Conservation Institute, this one is the result of a great team effort. Being a part of the Los Angeles community, we felt it fundamental to provide a solid and varied view of the importance of the Watts Towers to the city and to the world.

Co-authors Bud Goldstone and Arloa Paquin Goldstone brought us their special knowledge on the subject and remained relentlessly enthusiastic throughout the course of the project. John Farrell helped considerably with the first drafts of the book. Neville Agnew, of the Getty Conservation Institute, reviewed the manuscript and the layout with his usual clarity. Chris Hudson, of the J. Paul Getty Museum, brought to the project his constant support and enthusiasm, as well as his expertise in the field of publishing. We have found in Mr. Hudson a committed and constant partner. Mark Greenberg, also of the Getty Museum, reviewed the manuscript with meticulous care. The wonderful design of the book is the work of Vickie Karten, whose creativity and excellent sense of visual impact is unquestioned. As she has done in the past, Anita Keys undertook this project with complete dedication, good common sense, high professional skills, and great humor—always needed in complex projects under time constraints. She shaped and edited the manuscript and pulled all the pieces together. Sculptor Richard Oginz generously shared his passion for this Los Angeles landmark with us.

To all of them we are indebted.

Miguel Angel Corzo
Director
The Getty Conservation Institute

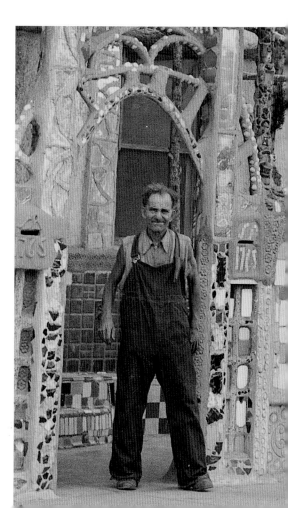

Back Cover:
Rodia climbing the Gazebo spire.

Photographer unknown,
ca. 1950. Courtesy Archive
Photos.

Rodia in front of the entrance to his house.

Photographer unknown,
ca. 1950. Courtesy Archive
Photos.